REMEMBERING
JACKSONVILLE

REMEMBERING
JACKSONVILLE
By the Wayside

DOROTHY K. FLETCHER

THE
History
PRESS

Published by The History Press
Charleston, SC 29403
www.historypress.net

Cover: Painting by Beckie Saar Leone of the Main Street Bridge (John T. Alsop Bridge)
as seen from Friendship Park in Jacksonville, Florida.

First published 2010
Second printing 2011
Third printing 2012
Fourth printing 2012

Manufactured in the United States

ISBN 978.1.59629.781.4

Fletcher, Dorothy K.
Remembering Jacksonville : by the wayside / Dorothy K. Fletcher.
p. cm.
Summary: "By the wayside" columns from the Florida times-union about life in
Jacksonville, Florida, during the 1950s, '60s and '70s.
ISBN 978-1-59629-781-4
1. Jacksonville (Fla.)--History--20th century--Anecdotes. 2. Jacksonville (Fla.)--
Social life and customs--20th century--Anecdotes. 3. City and town life--Florida--
Jacksonville--History--20th century--Anecdotes. 4. Jacksonville (Fla.)--Biography--20th
century--Anecdotes. I. Florida times-union (Jacksonville, Fla. : 1903) II. Title.
F319.J1F55 2010
975.9'12063--dc22
2010001397

For my father—who made this book possible by bringing his family to Jacksonville in the first place.

CONTENTS

CONTENTS

INTRODUCTION

I am a transplant, as are so many of us in Florida. At the tender age of seven, I was plucked from my comfortable home in East St. Louis, Illinois, and brought to the land of palm trees, beaches and oranges—a virtual paradise. It took us a while to totally embrace the place, however, since our introductory winter proved to be a bit different from what the travel brochures would have had us believe.

My family had been told by the realtor, who helped us find our rented house, that people in Florida didn't need furnaces. The winters were so mild in Jacksonville that space heaters would do just fine. We happily moved to the west side of town into a cinderblock house with jalousie windows.

A few weeks later, we watched with rising concern as the Great Snow of 1958 blew through, almost freezing my entire family in one frosty swoosh. I can still see my grandfather, who had come from Iowa to visit. He sat on the sofa of our new house, dressed in his overcoat and fedora, cursing the snowflakes as they fell just beyond our drafty windows and onto his Florida vacation.

This particular weather event almost set the record. According to George Winterling, meteorologist emeritus at Channel 4, WJXT, in Jacksonville, "The snow occurred on February 13, 1958. Snow depth was 1.5 inches. It fell on the anniversary of Jacksonville's heaviest snow on February 13, 1899, when 1.9 inches fell with a low temperature of 10 degrees."

It wasn't that my family couldn't handle the snow or the cold. We once owned snowsuits, galoshes and mittens; but when we moved to Florida, we

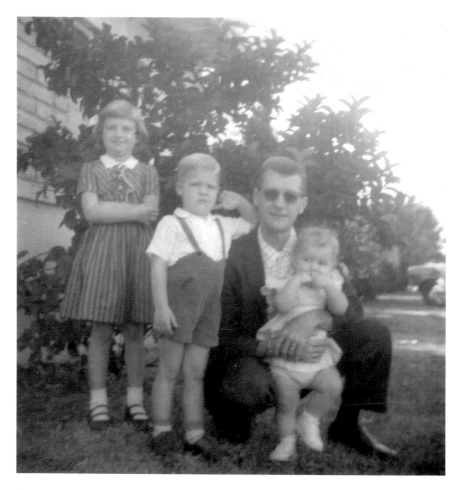

This is the Ketchum family in 1958, not long after their arrival in Jacksonville. They are in front of their new Florida house. Robert Ketchum, the father, is holding Elisabeth, the baby. Katie, a fourth child, who is not pictured, has yet to be born. The mother is not in the picture, either. She is holding the camera. Scott is in his suspenders, and Dorothy is the seven-year-old standing with arms folded.

gave away all those things to the poor devils we were leaving behind. How I longed for those clothes as we sat huddled around the small space heater in the hall, trembling with our beach towels wrapped around our shoulders and our breath making little clouds of sighs as we endured.

Once the winter had passed and we had moved to the Southside to a new subdivision with houses having furnaces, things became considerably better for my family. We settled in, planted shrubs and trees and began the process of putting down roots. I have been here in the same neighborhood

in Jacksonville ever since, with only one short four-year period away in Tallahassee at Florida State University. Barring unforeseen calamity, I shall be here in Jacksonville forever.

For me at least, Jacksonville is a salt-of-the-earth kind of place. It is basic and wholesome, but it has just enough spiciness and grittiness to make it interesting. It may not be the tourist capital of the world, as Miami or Orlando might be, but for those of us who have made this place our home, Jacksonville is almost heaven. It holds within its city limits wonderful places to grow, play and contemplate the beauty of north Florida. We have our river and our ocean and huge moss-laden oaks lining many of our roads. There are beautifully restored buildings that honor our past, and there are places that carve us a new space in the land.

When I first pitched this column idea to Phillip Milano at the *Florida Times-Union*, a book wasn't even a distant thought, but it became apparent after I had been writing "By the Wayside" for a while that I was not alone in my assessment of the wonders of Jacksonville. Others were also interested in the Jacksonville of our youth. Many citizens—native sons and daughters and transplants like me—thought that the '50s, '60s and '70s were golden years in the history of our city. It was the time when we began to experience the world with our own sensibilities and not those of our parents and teachers.

As I continued to write my column, I received many e-mails from readers and friends who wrote to share different aspects of Jacksonville that I had failed to mention in my column. These added facts and perceptions provided new insights and gave a deeper texture to my stories. Therefore, I felt it was important to include, along with my expanded essays, the e-mails I received. This combination of points of view helps to make this book more accurate than if it only held my views.

During the many interviews I conducted, I also realized that we baby boomers came into our own during an extremely exciting time, not only for us but for the whole world. It was the time of space exploration, new musical styles and changing social structures. It was also a time of great tragedy and fear.

As I was doing research in the microfilm section of the new Jacksonville Public Library's Main Library, I realized that the past was not all happy times. The *Florida Times-Union* was loaded with bad news, and on any given day in the "good old days," I could read articles about rapes, child abuse, embezzlements, bankruptcies, arsons, murders and robberies. The global situation was often bleak, as well. The Cold War loomed in our lives, threatening with mushroom clouds and annihilation what I remember as

a "Beaver Cleaver" kind of existence. As I whirred through the microfilm reels, I was sometimes shocked by the brutality of the news.

In all fairness, though, today's news outlets are still pretty grim. Bad news always seems to dominate. Stories about simple pleasures and joyful pastimes are relegated to the less important pages or time slots, and they certainly are not nearly as numerous as news stories with scandal and mayhem.

So, it seemed to me that a book that sees the world through the adolescent eyes of an earlier generation was long overdue. It would be nice to remember what it was like to see the world and Jacksonville with a sense of wonder and enthusiasm as when we were young and at the start of our lives—as when I was huddled up with my family in my cold Westside rental house wondering what else life in Jacksonville would hold for us. I must admit, however, that the warm winters have outnumbered the cold ones, and life in Jacksonville has been all I could have hoped it would be.

HOWARD JOHNSON'S WAS THE PLACE
FOR COOL REFRESHMENTS

March 18, 2008

Jacksonville was a different place forty years ago. Hans Tanzler was mayor, city and county governments had just been consolidated and *Rowan & Martin's Laugh-In* was the most popular television show in America.

Sally Martin Newkirk is fifty-seven and presently the director of Roswell United Methodist Church's preschool and kindergarten in Marietta, Georgia. She had just graduated from Wolfson High School, and during the summer of 1968, she became part of an American institution: the Howard Johnson's Restaurant chain.

Jacksonville had three Howard Johnson's in that year—one on Ramona Boulevard, one on Golfair Boulevard and one on Philips Highway. Sally worked as a waitress, or "HOJO Girl," at the Philips store.

These three havens of the highway were a tiny part of a huge empire started in 1925 by Howard Dearing Johnson. The chain of restaurants ran through the United States, mostly near major highways. At one time, the chain could boast of more than one thousand stores.

Johnson realized that the most successful part of his first business, a drugstore, was the soda fountain, which he stocked with his homemade ice cream. From that drugstore, he moved to ice cream stores and then to restaurants and finally to motels.

It's the ice cream Sally remembers best. Because she was allowed to eat all the ice cream she wanted, she tried all of Howard's twenty-eight flavors

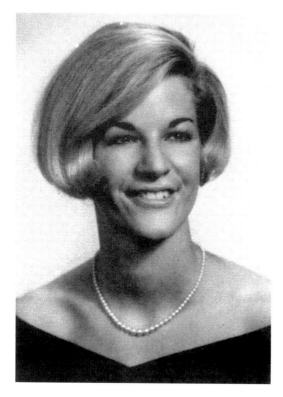

Left: The senior picture of Sally Martin Newkirk in the 1968 *Rhombus* of Samuel W. Wolfson Senior High School in Jacksonville, Florida.

Below: This is a postcard of the Philips Highway Howard Johnson's Restaurant. It had been mailed to San Antonio in 1956. *Courtesy of the Jacksonville Public Library, Florida Collection.*

and liked them all. "I wasn't too picky. Every day after my shift, I would help myself to a big serving of the flavor of the day while I waited for my sister Margie to come and pick me up."

The commercials of the time lamented in a cheesy song that "vanilla was the loneliest flavor under the orange roof" of Howard Johnson's. And it probably was, with flavors like Peppermint Stick, Caramel Fudge and Burgundy Cherry.

"I suppose if you pressed me on it, I'd have to say my favorite was Pistachio Nut. Although that Swiss Chocolate Almond, with all those whole nuts, ran a close second," Martin said.

Back in those days, Jacksonville residents had to work hard to beat the heat. Not many families had air conditioning yet, so they would often spend the warm evenings on porches, calling to the neighbors, or in backyards sitting under the cool shade of trees. Oscillating fans were all the rage, and so were cool treats. Nothing was better on a hot Jacksonville afternoon than to load up the car with the family and head for the nearest "Landmark of Hungry Americans," the Howard Johnson's Restaurant.

There, families could escape their hot houses and sit at cool, gleaming counters or tidy tables. And with the help of HOJO Girls like Sally, they could bury their appetites in huge hot fudge sundaes or cones of mint chocolate chip ice cream. They could spend a pleasant hour in Howard's hospitality before they had to return to the heat and humidity.

At the beginning of the summer of 1969, Hans Tanzler was still mayor and *Laugh-In* was still number one in the TV ratings. I had just finished my freshman year at Florida State University, and I needed a job to help cover college expenses. I soon joined Sally and the ranks of the HOJO Girls of America.

I donned the turquoise houndstooth shirtwaist uniform and white orthopedic shoes every morning. Then, I would stand proudly behind the gleaming fountain at the Howard Johnson's at Golfair Boulevard right next to Interstate 95. It was my first job, other than babysitting, and it was the hardest job I have ever had (and that is saying something since I was a high school English teacher for thirty-five years).

It was quite a long day starting at 4:00 a.m. when I would awaken to be ready for work by 5:00 a.m., my starting time. The store opened at 6:00 a.m., and I didn't stop until 3:00 p.m. when my shift ended. I was absolutely exhausted from taking and filling orders, bussing tables, carrying heavy trays and working the counter. My feet ached badly at first until I learned from a veteran waitress to soak them in hot water each night. Since my days as a HOJO Girl, I have been a big tipper.

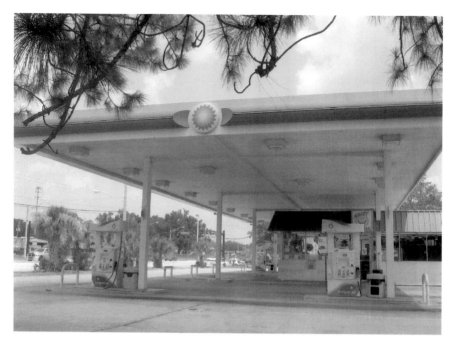

The BP Station that now stands where the Philips Highway Howard Johnson's once stood.

We served so many wonderful things under the orange roof of Howard Johnson's. I remember a thing called the Toastee, which we would serve at breakfast in place of toast. When it was slathered with marmalade and butter, it was fabulous. Our short-order cook could prepare the best eggs and bacon breakfasts in no time at all to go with that Toastee, and Yankees almost always wanted to experiment with this thing called "grits" that came with all breakfasts.

At lunchtime, along with traditional fare, we served a thing called a clam roll. It had a hot dog–like bun filled with fried clam strips. It proved very popular with countless tourists on the road to somewhere else.

The job at Howard Johnson's wasn't all hard work. I learned all the basics of ice cream and became quite the expert at making sundaes or strawberry shortcake delights. The picture manual of Howard Johnson's confections was my Bible, and it made my mouth water just flipping through the pages. Of course, I had ice cream as my lunch whenever I worked the counter.

Like Sally, my personal favorite flavor was Pistachio Nut. The velvety, light-green scoop filled with nuts was all I needed to get me through the grueling hours of serving tourists on their way farther south. I also loved

Swiss Chocolate Almond, but even the plain flavors were heavenly to me. Strawberry had whole berries floating in each bite. The Peach was filled with big slices of peach.

It is sad that such wonderful places and times must make way for progress and become part of hazy memory. In the United States, only three Howard Johnson's Restaurants survive today. In Jacksonville, however, the Ramona, the Golfair and the Philips Highway Howard Johnson's Restaurants are out of business, replaced by more necessary places.

The Ramona location has been leveled and is under construction. At the Golfair and Philips locations, BP Gas Stations now stand, bright, clean and shiny, with little evidence of the Howard Johnson's Restaurants or what they represented to earlier generations. The only things that remain are the musings of those of us who remember simpler times—when all could be made better by a trip to the nearest Howard Johnson's for a scoop of his famous ice cream.

E-mail responses to the column:

> Dear Dorothy Fletcher,
> Thanks for the Howard Johnson's article! More than just another business it became an institution and an important part of many people's lives. I have been documenting the roadside empire online since 2000.
> Here is my site about HOJO's as well as a link to lesser known roadside operations which I have also endeavored to document:
> www.orangeroof.org
> www.highwayhost.org
> Rich Kummerlowe
> PS. I have even posted several commercials on YouTube including the one you mentioned about vanilla being the loneliest flavor.

<p style="text-align:center">* * *</p>

> Thank you...thank you so much!
> I have been so disappointed with the newspaper lately from them changing the crossword puzzle in the ad section to being so small and the notice of obituaries being scattered over the page not being alphabetized

because they say lack of space so I wanted to let you know how pleased I was to read the *Sun* issue this morning! The front page was very interesting, the Pipeline (Highlights, Around Town) was excellent (I read those on Monday's too) and I thoroughly enjoyed the article about Howard Johnson! I, myself, was a HOJO girl at the Philips restaurant in late '66. I was older than Sally, but it brought back some wonderful memories of those days.

I hope you continue to write articles like this from around our city!

Maryann Turley

* * *

Dear Dorothy—your column brought some smiles as I was a HOJO girl the same time that Sally was. I worked on the Massachusetts Turnpike and was there the day that Janis Joplin was refused service for not wearing shoes...I STILL can taste the wonderful Swiss Chocolate Almond—my favorite. And yes, I gained weight from all of the ice cream! But scooping out all of that ice cream also helped me to take a backpack trip to Europe (on $5.00 a day—that was a joke) and pay some college expenses. Because my two sisters worked there at the same time and we all had to wear hairnets, we played all kinds of tricks on the customers (Back then our name tags actually had Miss before our last name...) Ah such sweet memories you have given me today.

Claudia Scott

* * *

I enjoyed the article about HOJO's.

I have a challenge for you...I remember as a child going to a story book park. It was on Arlington Expressway, east of University Boulevard and across the highway from Town & Country Shopping Center (I think there are apartments there now). There were Mother Goose and other children's stories settings scattered through

the park. It was not a theme park, but a wooded area. This would have been late in 1950s.

So, is there a story to be found?

Another story idea—same time period, there was children's horse-riding spot at NW corner (out-parcel area in front of Kmart) of Beach & University (which was called Longwood Road back then)—there were 2-3 speeds to choose from: slow, (medium) and fast.

Keep up the good work!

Valerie Bennett

* * *

Hi Dorothy,

I was just enjoying some of your past columns eating lunch here with my computer screen, and I'm feeling compelled to respond to the "Howard Johnson's" piece. Gosh, what memories that evoked! It was a huge treat for me as a child to be taken to "HOJO." For all the years I went, my order never varied: hamburger with french fries, a dill pickle spear, and for dessert, butter-pecan ice cream, my favorite!

Thanks for bringing back such a happy time. I think I know what I'm fixing for dinner tonight...

Take Care,

Meg Fisher

IN 1960S, SURFING TOOK HOLD
AND NEVER LET GO

April 11, 2008

It has been said that there are two types of people: those who live at the beach and those who wish they lived at the beach.

While this may be true, many Jacksonville residents never let a few miles get in the way of enjoying a 1960s phenomenon—surfing. They spent many hours becoming part of a new subculture celebrated in song and *Beach Blanket Bingo*-type movies. Because we "had an ocean" nearby, we gladly became part of "Surfin' USA."

It was in 1966 when Mandarin resident Scott Ketchum—now fifty-four and general manager of Nanak's Landscaping—turned on to surfing. He had just turned thirteen.

"My first board was almost twice as tall as I was, nine feet six inches long. It was so big I couldn't even get my arm around it, so I had to carry it on my head. But I loved surfing so much. It was worth all the effort to do it," he said.

Scott's imagination was captured by the surfing experience. In the same year the Beach Boys released "Good Vibrations," Scott and his fellow surfers were out every weekend at Access 5, now Hanna Park. Or they would be shooting the curl at the Atlantic Beach Pier near the old Le Chateau Restaurant. Or they traveled to Crossroads to catch a few waves there.

I was still too young to drive, so my mother would take a bunch of us in the early morning and drop us off at a beach. Then, in the late afternoon,

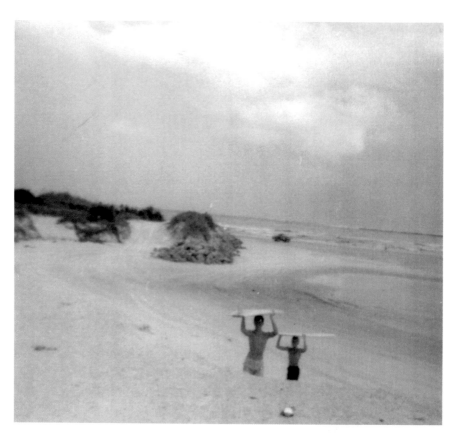

Boys with surf boards in late '60s. *Courtesy of Rick Weigel.*

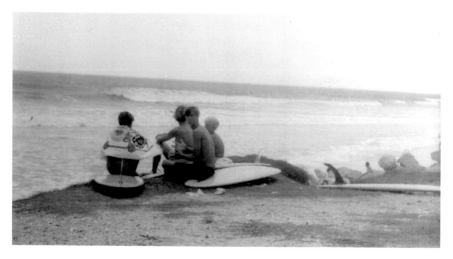

Surfers resting on shore at Crossroads in late '60s. *Courtesy of Rick Weigel.*

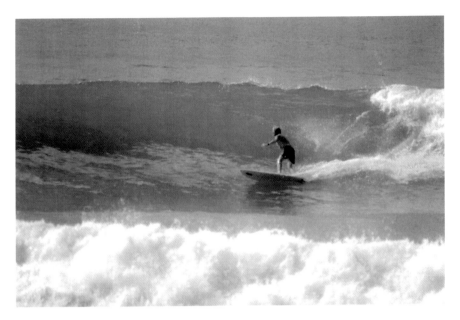

An adult Scott Ketchum surfing off the coast of Costa Rica. *Courtesy of Scott Ketchum.*

another guy's mom would come and pick us up. When I was sixteen, I got a 1960 VW Bug, which could hold four surfers and four boards on a rack. It was great. Each of us anted up twenty-five cents to get some gas, and then we were good for the whole day.

Occasionally, Scott hitchhiked to the beaches. "It was not my preferred method of transportation, mostly because I had this huge board with me. But it was safe enough to do, back in those times. Someone always came by."

Scott also recalls that Hixon's Surf Shop was an important part of the scene. This place operated from 1965 to 1990, providing all sorts of beach needs. Every day the guys wanted to surf, they would call Hixon's first to get the "surf report."

Even now, surfing is a big part of Scott's life. He and his grown friends often make surfing junkets to such places as Costa Rica, Peru, Panama and Mexico. These countries have much larger, better-formed waves, but Scott's heart is still here in northeast Florida. "I think surfing was and still is a great opportunity to be outdoors. And when the surf's up, I'm there. It really appeals to me. There is a sense of freedom that comes with surfing. There is nothing better than riding in on a good wave and seeing a dolphin surfing in right beside you. How cool is that!"

Of course, there are those whose surfing experiences were not always so idyllic. Take for example those of Rick Weigel, fifty-six, a dispatcher/driver for Manning Building Supply. He recalls many after-school trips to the beach to ride the waves and enjoy the ocean. There were three special places where he and his friends would often go—Crossroads, Accesses 1–5 and the North Jetties or Playa Norte near Huguenot Park.

"In order to get to the North Jetties, you had to ride over powder fine sand, and since there were so few four-wheel drive cars in those days, people would get stuck in the sand all the time. I'll never forget the time when my future brother-in-law, Bruce Saar, and I got stuck while we were in my '66 white Rambler Rogue."

Of course, that beats the day that Rick and Bruce encountered a shark at the North Jetties.

I was about fifty yards off shore, and we didn't have leashes back then. I had lost my board, and I was going in to retrieve it when here comes Bruce really shook up because a huge shark had just passed right under his board. Of course, here I am out there with no board at all. I quickly made it to the rocks.

My scariest shark encounter was at Crossroads. I had just wiped out in a somersault and was somewhat disoriented when I hear people yelling "Fin! Fin!" I thought they were talking about the fin on my surfboard since

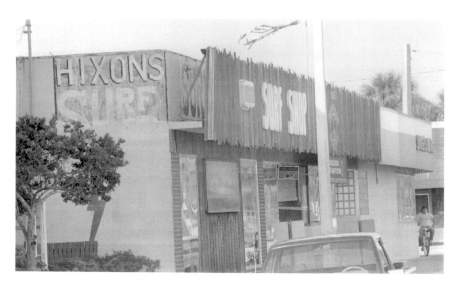

Hixon's Surf Shop in Atlantic Beach in the late '60s. *Courtesy of Mitch Kaufmann.*

it was floating in upside down. But no. I suddenly see the black dorsal fin of a shark and all sort of shark survival lessons flashed through my mind. I was probably the second man to ever walk on water or at least it looked like that. I made it to my five-foot, six-inch board and tried to fit my six-foot frame on it. I made it in with my legs up, and when I finally got to shore, I had to put my head between my legs for fear of fainting. The next day at school word got around that I had been attacked.

In any case, most of us lived to tell tales of our surfing times—scary or magical. And now that the bones are a bit creaky and it takes a great deal more effort to get out to the good waves, surfers still enjoy that happy glow of youthful enthusiasm when they talk of their glory days at the beach—a glow somewhat like that of a deep suntan.

STILL ROCKING, MORE THAN
FORTY YEARS LATER

May 22, 2008

Whether it was a sock hop in the school cafeteria or a formal cotillion at Mother's club, Jacksonville teenagers of earlier generations had many opportunities to dance "their kind of dances to their kind of music."

I used to attend the dances at the Southside Women's Club, the Beach Pavilion and even my neighborhood's Grace Chapel Recreation Center. And there were other clubs I never got to, like the Westside Teen Club, also called the Sugar Bowl. All of these places had one thing in common: local garage bands made up of our friends, classmates and stars-in-the-making. They replicated the styles of more famous groups such as the Kingsmen, the Zombies and the Beatles, and they provided an appropriate atmosphere for the dances Jacksonville youth of earlier generations really enjoyed.

Southside resident Lyn White, now sixty-five and a medical assistant at Southern Heart Group behind Memorial Medical Center, remembers very well some of those wonderful dances and the groups that provided music:

> *The dances were held at the Friday Musicale and Riverside Woman's Club on Friday nights and maybe Saturday, but I am not absolutely sure about Saturday. The J-Notes were a black band that often played for these dances, and they were great! This was when the "Twist" was "The Dance." We would go every Friday night for sure. I remember there was also a band called the Lemon Twisters, also a black band, and I think they played*

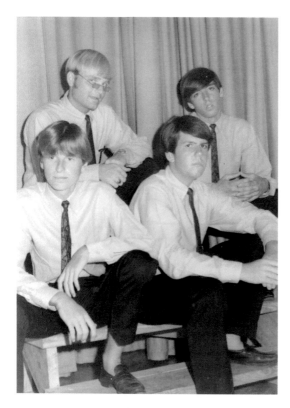

Left: Soul Searchers promotional picture, 1967. *Courtesy of Tim Ballentine.*

Below: Tim Ballentine playing his guitar with the Soul Searchers at a Saturday night dance in Jacksonville, 1967. *Courtesy of Tim Ballentine.*

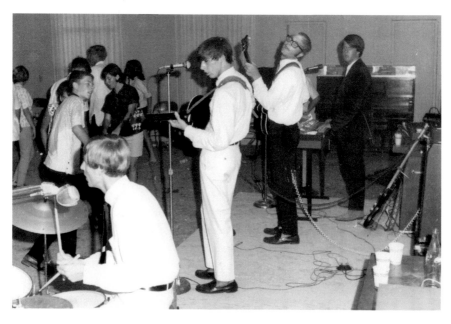

after the J-Notes. The lead man in the J-Notes was Henry Hodge and the female singer was Everlina.

Another great place where teen dances took place was at Grace Chapel Parish, now called San Jose Episcopal Church. Here the EYC, or the Episcopal Young Churchmen, sponsored dances in the old Parish Center. According to an article by John T. Roberts in the September 1967 edition of the church's newspaper, the *Grace Chapel News*, things got off to a slow start that year:

> *In June, we were starting with an unknown band, with little resources for much advertising, and a location which was not established as an "in" place to have a dance. Since that time, however, all has changed! The ESSENTS have developed quite a following, there is money for extensive advertising on Radio Station WAPE (The Big Ape, Number One in Jacksonville)… Our first night had 24 people…a few nights ago we had in excess of 300.*

Admission was $1.50 per person, and the dance lasted from 8:30 p.m. to midnight. By the end of the summer, the dances were held twice a week.

According to an earlier news article in the July edition of the *Grace Chapel News*, the ESSENTS was a rock band from Nashville, Tennessee, "summering in Jacksonville while working on the soon-to-be-released single 'Very Sometimes.' The ESSENTS sound varies from folk-rock to mildly psychedelic." When the ESSENTS "took a brief holiday, the EYC brought in the ODYSSEY."

Closer to the beach was another local band that provided the sound for many dances in the area. The Soul Searchers were four students from Fletcher High School who came together to be part of the musical revolution of the decade. They played gigs as far south as Daytona Beach, as far north as Savannah and as far west as Tallahassee. For four years, they played to appreciative crowds at weekend dance venues across northeast Florida.

They also opened for some pretty impressive groups: the Left Banke at the Beaches Pavilion and the Animals at the Jacksonville Veteran's Memorial Coliseum. They even had their rendition of "Can I Get a Witness?" hit No. 1 on WAPE for a number of weeks in 1967. Sadly, no record contract came. It didn't matter. Playing the music seemed to be as important as making it a life's work.

Tim Ballentine, sixty, now executive director of Instructional Research and Accountability for the Duval County School System, was and still is a

Above: Beach Pavilion, site of many dances and where the Soul Searchers played, 1975. *Courtesy of the Florida State Photographic Archives.*

Below: Present-day Soul Searchers. *Courtesy of Tim Ballentine, 2006.*

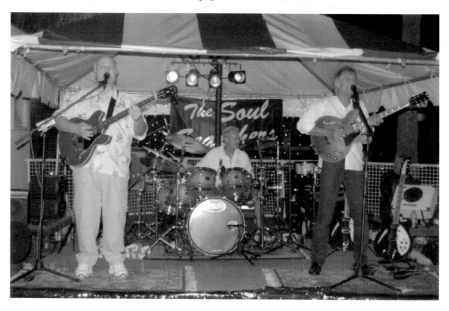

bassist and sometime keyboard player. In his Buddy Holly black glasses, he wowed the kids back in the day as lead singer for the Soul Searchers with such songs as "If I Needed Someone" or "Tell Her No."

"I was inspired by the guys that I hung out with. They even had to teach me how to play the guitar," Ballentine said. "And the music—it was the music, really, that made us come together as a band."

Anthony Martinich, fifty-nine and now senior project manager for Fidelity National Financial Information Services, was and is lead guitarist. He echoes a similar sentiment. "The music or songs we played, they hold great memories of being with these guys. They also represented our age group. I really loved that time period."

Fred Hawkes, fifty-nine, is a lawyer at a firm in Tallahassee. He was and is the drummer for the group. Drew Lombar, who played lead guitar, completed the quartet. Two years ago, after a career as a professional musician, Drew died of a heart attack at age fifty-seven.

The Soul Searchers play on now as a trio and have headlined at the 2008 and 2009 Fletcher High School's Annual All Class Reunions. They play for various reunions and Christmas parties at places like the Southside Women's Club, the Moose Lodge and the Springfield Women's Club.

Ballentine still gets a great deal out of being part of the band as an adult. "If people are willing to listen, I am willing to perform." Martinich still enjoys being part of this band because he wanted his daughter "to come to enjoy a different, better kind of music."

If you happen to have been lucky enough to hear the Soul Searchers perform, back then or anytime, you need only close your eyes and become sixteen again and at one of those wonderful neighborhood dances, swaying to the hopeful music of a younger, vibrant time.

E-mail responses to the column:

> Hi, there. Just wanted to write to you and comment on the article about the Soul Searchers. A friend in Jax, M.J. Trenkler, sent me the article. I was the morning guy at WAPE from 1967-1971. We played the Soul Searchers records and did the MC work for a lot of their concerts. Can't believe they're still playing. They were very good. Unfortunately, they never got the break to make the Big Time. Probably just as well. From the article it sounds like they made good lives for themselves with "real jobs." Thanks for mentioning WAPE, too. We sure had a

lot of fun in those days. I never could believe they paid all of us to work there at such an enjoyable job. When I'm back in Jax now (I live near Tampa) and tune into the "Big Ape," my stomach turns. I really got hit between the eyes when I drove through Orange Park and saw the old "Big Ape" studios were now a retirement home! As Miriam Hopkins once sang, "Those were the days, my friend. We thought they'd never end." Sadly they did. Thanx again for the WAPE mention. JIM SHIRAH

* * *

What a nice reply! Thanx Dorothy. I loved working at the APE. Grew up listening to it in Daytona when I was a kid and never dreamed I'd be working there. I thought everybody in Jax listened to it, but when I got to town and did an informal survey, found that WPDQ was number 1. What a surprise! Luckily though I was able to put together a good staff of Dale Kirby, Honest John, Alan Sands and Ron Wayne, and we became #1 within 6 months of our arrival and stayed that way for the 4 years I was there. 2008 is the 50th Anniversary of WAPE going on the air and the present owners are supposedly planning some festivities where they will bring back us "Old Timers" to talk about the good old days. Sure did enjoy my time in Jax. Got to meet Elvis, was DJ of the week on *American Bandstand*, written up in *Teen Magazine*. Lots of good stuff. Very fond memories. Sadly, those days of "real radio" seem to be gone. No more "personality" DJs that got to infuse their own personality in the shows. Would look forward to talking to you and answering any questions you may have. God bless and have a great Memorial Day. JIM

* * *

Mrs. Fletcher,
A friend from Jax sent me a link to your recent article about the Soul Searchers. I was a dj at WAPE AM from 1966 until 1971. WAPE (The Big APE) signed on in 1958, so this is the 50th anniversary year. Of course, the call

letters are now owned by Cox Radio and are assigned to an FM frequency and the frequency (690am) now has different call letters...so the old station is gone. Even so, it was a 50,000 watt rock and roll giant in the 60's—usually #1 in Jacksonville and often rated among the top two or three stations in Daytona, Savannah, Charleston and all the other towns between Cape Canaveral and Cape Hatteras.

There is a wealth of information about the Big APE at http://limestonelounge.yuku.com/topic/1379. It was a wonderful radio station and a great place to work. If you'd like to do an article and need any information from me, feel free to ask. I am retired now and just returned from a pelagic birding trip out of Cape Hatteras. We stopped for breakfast at a little place in Hatteras and were talking to a local resident who was born and raised there. I asked him what radio station he listened to as a teenager and he said, "Some station out of Florida." I said, "Was it WAPE?" "WAPE...maybe." I said, "The Big Ape?" and he said, "Yeah, yeah...that was it...the Big APE." I said, "Do you remember a disc jockey called 'Honest John'" and he said, "Oh, yeah... Honest John." I told him that was me. It was a really nice moment for me.
John Ferree

* * *

Dorothy,
Thanks for your story on The Soul Searchers. Hope you and your husband can come out to hear us play sometime. I am sure Tim will let you know when we play again.
Anthony

* * *

Hi there. Was just going thru my WAPE folder and came across your email. How's things Jax way? Sure miss it up there. Still stay in contact with some friends. Remember Pete from Mouse and the Boys? He and I email very

often. Honest John and Alan Sands too. Sadly, Dale Kirby is dead. Hey, you need to go to dreamcruise.com and check the big weekend coming up in Daytona, Oct 24. I'm putting in an Elvis "Images of the King" Contest with up to 23 guys competing to go to Memphis next August to compete with others from around the world to be the best Elvis. Maybe get a bunch together from the old days and come down and have a mini reunion. Hope things are great for you and yours. JIM SHIRAH

GOING TO THE MOVIES WAS A
WALK THROUGH CINEMATIC HEAVEN

June 19, 2008

For those of us who love the movies, one or two special moviegoing experiences usually stand out in our minds. One special Jacksonville theatre, where cinematic good times were many, was the (long-closed) Center Theatre. The Center Theatre was in a building that opened in 1912 as a vaudevillian theatre. This later became a movie theatre called the Arcade in 1915.

On August 8, 1960, the Arcade became the Center Theatre, and its first featured movie was *Ben-Hur*. The theatre was in the "center" of the block bordered on the north by Laura Street and on the south by Main. Moviegoers could enter from one of two streets—Adams or Forsyth.

San Marco resident Hal Kelly, sixty, owner of Indoor Comfort Air Incorporated, was there at the Center the night when *Ben-Hur* opened. "I was about ten years old. Since my dad was out of town, my mother took me. I had to wear a coat and tie, and I thought the whole experience was peachy keen. No really, the programs were hardbound books, and I was very impressed with the theatre experience."

Margo Dovi Feichtmeir, fifty-seven, who now lives in Seattle, Washington, remembers very fondly the wonderful theatre experiences the Center provided her. When she was a young girl growing up in Jacksonville, she and a few of her junior high school chums spent many summer hours lost in the dark movie auditorium of the Center Theatre.

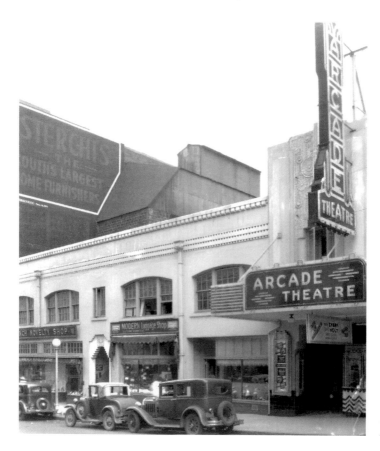

The Arcade Theatre in 1927, which would become the Center Theatre in 1960. *Courtesy the Florida State Photographic Archives.*

In 1963, the year when David Lean's epic *Lawrence of Arabia* won seven Academy Awards, Margo and her friends coaxed their parents either into taking them in the car or allowing them to ride the bus downtown so they could become lost in the joy of movies at the Center.

"Today's multiplexes can't compare to the luxurious expanse of those old widescreen movie theatres and the enveloping experience of seeing a movie like *Lawrence of Arabia*, made for such a screen," Feichtmeir said. "I recall velvet drapes opening as the lights dimmed, the first scenes of desert and that gorgeous music surrounding us, suspending time and reality. No wonder we kept going back!"

For the three and a half hours the movie lasted, Margo and her friends were in cinematic heaven. And believe it or not, they watched this movie at least four times together before the summer was out. "The movie was so long that there was an intermission, and we used the time to buy souvenir programs, complete with pictures of our heartthrobs, Peter O'Toole and Omar Sharif."

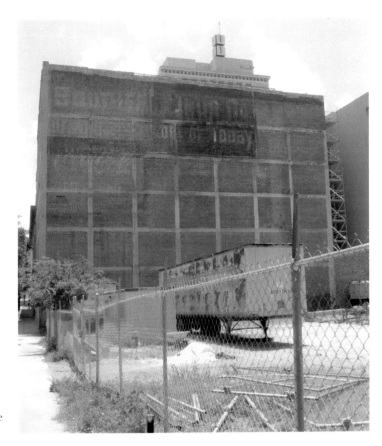

A vacant lot where the Center Theatre once stood.

But as every moviegoer knows, there comes a time for the final credits to roll. Margo and friends went back to school books in the fall, and Margo's family would soon move to Tampa, splitting up the group of movie buddies forever.

After a twenty-three-year run, the Center Theatre closed on January 2, 1983. The last featured films were kung fu movies *Don't Bleed on Me* and *Flying Guillotine*. The Center was the last downtown theatre, other than the Florida Theatre, to close.

There is a bittersweet feeling one gets looking at the empty space on which the theatre once stood. The vacant lot filled with weeds and construction tools awaits a renovation project. One can only imagine all the multitudes who were entertained in that space.

Margo and the girls grew up and moved on to happy and productive lives, and for them, at least, the Center Theatre and the movie *Lawrence of Arabia* still live in pleasant memory that is hard to duplicate today.

E-mail responses to the column:

Hello Ms Fletcher—I enjoyed your article about the Arcade Theater. We went to that movie at least once a week. I may be wrong BUT I think that it [the Center Theatre] was bordered on the NORTH by Adams Street and on the SOUTH by Forsyth Street—on the EAST by Main Street and on the WEST by Laura Street. Anyhow, I would like to tell you a little tale about this girlfriend of my wife. She came down from a small town in Alabama to spend several days with us (late 40's or early 50's). The wife worked the evening shift at Fletchers Restaurant and I had a shift that ended at 10:00 p.m. We took her to the entrance of the theater, told her to be at the entrance about 10 minutes after ten and we would pick her up and then go get the wife. Well, I got to the entrance at ten past ten, no Essie to be seen. I waited several minutes thinking that she would be out momentarily.

After several minutes had passed, I thought maybe she had gone out the other entrance on Forsyth. So I go there, and after looking up and down the street I spotted her walking almost to Main Street—there I go in a hurry and whistling (sort of a wolf whistle). She heard the whistle but sped up the more faster—I guess that she was scared to death (in a strange town, a wolf on her trail, and no help in sight), but I finally shouted her name and she turned around and saw it was me. She didn't let us out of her sight any of the time left that she stayed with us.

Eponder

Note: I did have my directions mixed up. The Center Theatre was bordered on the north by Adams Street and on the south by Forsyth.

RIDING HORSES BACK IN THE DAY WAS A
GOOD TREAT FOR CHILDREN

July 25, 2008

Most Americans of a certain age can remember falling in love with horses. How could we not, when westerns dominated TV programming of the '50s and '60s?

We watched such shows as *Wagon Train* and *Gunsmoke*, and many of us teenage girls had crushes on Little Joe Cartwright of *Bonanza* or Rowdy Yates of *Rawhide*. Teenage boys had the "cool" Maverick brothers as role models, and all our cowboy heroes rode magnificent beasts that carried the characters through prairies, over mountains and into sunsets on our TV screens.

Roy Rogers rode a palomino named Trigger. The Lone Ranger rode a white stallion called Silver, and Tonto was mounted on a pinto named Scout. Images of these powerful horses rearing up, bounding away and chasing bad guys became fixed in our subconscious early.

It's no surprise that when a man happened by our house with a pony, camera and cowboy outfits, we were beside ourselves with joy. Mandarin resident Bob White, now fifty-four and chief operating officer of Sleiman Enterprises, suited up as fast as any four-year-old would have when the time came for his photo to be taken.

"When I saw all that cowboy stuff, my eyes got big, and I was all over it," he said.

His beaming face was captured in a picture his mother carefully saved. It is almost the exact same picture as the one so many other mothers across

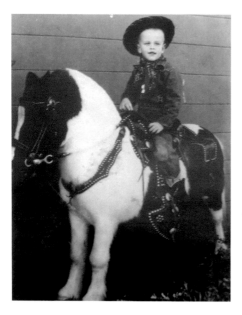

Four-year-old Robert White on a pony in 1958. *Courtesy Robert White.*

the nation have saved. Whether displayed in frames on top of pianos or placed in scrapbooks, there are these pony pictures preserved with grandmother photos and First Communion memories.

In the late '50s, riding the ponies was the best of all possible treats for little kids in Jacksonville. Southside resident Valerie Westbrook Bennett, fifty-six, an account representative at State Farm Insurance, can attest to that. She remembers fondly that there were pony rides at Beach Boulevard and Longwood Road, later renamed University Boulevard. "I was into speed back then," she says. Bennett almost always requested the faster pony circle. "It was a big treat back in those days to get to go there."

There were other wonderful places where kids could get to ride horses. Just beyond Jacksonville's old city limits, the countryside was still very rural. Many pastures and farms have since been converted to school campuses, apartment buildings and shopping centers. One great place for riding horses was the Circle C Horseback Riding Stables on Old St. Augustine Road in Mandarin. Huge, saddled horses were trotted out for kids to learn how to ride.

Little kids learned to ride in a meadow that was next to what is now the St. Joseph's Catholic Church, and the animals they rode all had such delicious names: Cinnamon, Honey Dancer and Taffy. These horses were the best of all possible playmates.

My parents gave me ten one-hour horseback riding lessons at Circle C, and I savored every moment of those hours. It was all my father could do to let his little girl climb high up on a monster of a horse and trot off into the woods with her instructor. But he let me go, and for that I thank him and my mother. It is probably the most memorable gift I have ever received, and even now, I am thrilled being near horses.

But some horseback riding memories are not exactly happy. Claire Fleming King of Mandarin, now fifty-eight and retired after a career at Bellsouth, had a very different horse story:

> *I had just moved to Jacksonville, and my mother wanted me to get acquainted with the girls in my neighborhood, so she signed me up in a Girl Scout troop.*
>
> *We went one day to Circle C, and it was my first time ever on a horse. I was a good sport and went along with the others as they moved ahead of me on a trail. Then, all of a sudden, my horse just stops. There I was, stopped dead in the...wood.*
>
> *No one came to my rescue. So, after about thirty minutes, I began to cry and eventually, when everyone realized I was not present at roll call, a stable hand came out to find me. I was horribly traumatized!*

Perhaps the love of horses is not shared by everyone, but Jacksonville of yesteryear provided many opportunities for children to enjoy (or not enjoy) equestrian pastimes. For me, it was simply grand to be out in the country, learning to manage the trot and gallop while remaining in the saddle. This, all while imagining myself as an incredible cowgirl! For ten lovely mornings, I was lost in fantasies of the Old West, and believe me, when it came to riding horses, I was all over it!

E-mail responses to the column:

Hello, Dorothy Fletcher—

I happened on your e-mail in an article on riding horses back in the 60s in Jacksonville when the pony rides were at Beach Blvd. and University Blvd.—and it referenced your column By the Wayside.

I was born and raised in Jacksonville—we left there in 1968 and moved to Atlanta. It has been many years since I've been back. I happened upon a blog w/some folks that were living in Jax around that time and they were chatting, and it brought back all kinds of memories.

There was the Skinner's Dairy locations—the weird buildings—and I think they were the ones that used to give away baby chicks at Easter—of course, they failed to mention that the chicks would all grow up to be nasty, mean spirited Roosters! I raised two and didn't even mind when we ate them at my cousin's farm about two

years later. And the dime stores used to have table after table of all kinds of fancy Easter chicks to put in your basket—they were on cardboard, and when you bought one, you detached it from the board that held it upright—all kinds, all colors, all sizes, all decorations—so many to choose from!

I lived in Arlington—on Ligustrum Road off of Rogero. I played in the creeks, rode my bike up every hill I could find (which wouldn't even qualify as speed bumps here in Atlanta)—took tap and ballet lessons from a lady that taught in an old house near the intersection of Rogero and Arlington Road—she was an institution, but I can't remember her name.

I remember when Regency Mall was built—and the dunes that abutted it were intact. Wonder if there are any left at all now. And Patti's Italian Restaurant over on Beach Boulevard. My most favorite place in the world to eat. Wonder if they are still there. Loved to go to St. Augustine on Sundays.

There were sandspurs everywhere you went, and doodle bugs to irritate out of their homes. There was WQXI and WAPE (both AM, of course) and 7-11 street dances with live bands. I drove everyone crazy playing the Beatles and Beach Boys and other 60s rock as loud as I could get it. Every week I had to decide which of all the new 45s I really had to have. There was a new TV station—on UHF—so radical. It was the ABC network—joining CBS and NBC—of course, our set wouldn't get the new channel. I ran around playing and lusting after "Man from UNCLE" (bought the DVDs the minute they were released!). Burger King had hot ham'n'cheese sandwiches called Yumbos (Wish they would bring them back.).

The local movie theatre (Arlington Theatre) was next to an A&W Drive In. They would have multiple feature movies for 50 cents—3 of the beach blanket/surfing flicks, or 3 Presley movies, or *Help!* And *A Hard Day's Night* and something else. We would go in like 11:00 and stay until supper. We should have had them all memorized.

I took a notion and started looking for pictures of the 1960s Beach Boulevard pony rides—I find allusions to them by many who used to ride the ponies back then, but I can't find any pictures. Strangely enough, even though I went there all through elementary school to ride the ponies, my mom failed to record this on camera. Could you point me to any existing photos? I would be most grateful.

If there's any way to subscribe to your column, please let me know. It's hard to believe I'm as old as I am—and how long ago this was. I was fortunate to live my childhood in such a time.

Bev

A STORM CALLED THE BEATLES HIT
JACKSONVILLE IN 1964

August 30, 2008

Not many people realize there were actually two massive "tempests" that hit the north Florida area in September 1964. The first was Hurricane Dora, our first real hurricane, which made landfall September 9. The other was the Beatles, the British singing phenomenon, who arrived September 11.

Both blew through here with a torrent of wild activity. According to the *Florida Times-Union* of September 12, 1964, the four boys from Liverpool stayed at the George Washington Hotel and performed in front of twenty thousand screaming Beatles fans in the Gator Bowl.

Reporter Frank Murray said they had "three times the normal amount of hair for young men their age."

The Mighty 690 WAPE radio station sponsored the event, which was a part of the Beatles' first United States tour. The charge was five dollars. Openers were Reparata & the Delrons, an all-girl group from Brooklyn; Jackie "What the World Needs Now" DeShannon; and the Bill Black (former bassist for Elvis Presley) Combo.

Other than the wild mobs of young girls, there was only one glitch. Before the "shaggy quartet" of Paul McCartney, George Harrison, John Lennon and Ringo Starr went on stage, they required newsreel cameramen leave the area. Because of an issue over royalties from the sale of the film, the Beatles refused to play until the cameramen left. Only then did they walk out on stage.

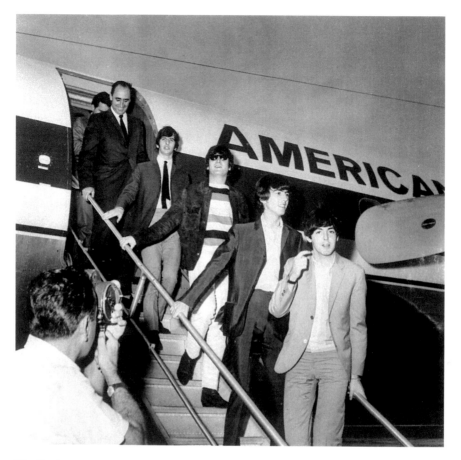

The Beatles arriving in Jacksonville at Imeson Airport in 1964. *Courtesy of the* Florida Times-Union.

San Marco resident Hal Kelly, now fifty-nine and owner of Indoor Comfort Inc., still has his ticket stubs. Of the concert, he says, "It was Fab!"

"I was lucky enough to be on the thirty-yard line. Unfortunately, I had forgotten to bring my glasses, so things were not all that clear. I could tell, however, that Ringo's cymbals and hair were blowing in the wind," Kelly says. "They played a thirty-minute set, but I don't think they did even twelve songs. Besides, I couldn't hear them for all the girls screaming."

Boca Raton resident Alan Oakun, fifty-seven and licensed realtor and marketing director, was there as well. "It was like a dream come true for me. How can I say it? It felt like I had fulfilled everything I had ever dreamed of. It was a kind of 'euphoria' hearing the songs you had already heard

Ticket stub from the Beatles' Jacksonville concert. *Courtesy Hal Kelly.*

countless times on the radio. But it was also very loud. It was not to be believed almost. There was such screaming and the next day I was so hoarse. I suppose I was screaming, too."

Southside resident Kathy Boyd Quinn, now fifty-six and a retired English teacher in the Duval County School System, was just twelve and one of the screamers. Her progressive mother and older brother escorted her to the concert of a lifetime, and Kathy was beside herself with happiness. "At the time of the concert, the weather was still pretty bad and windy. We got to sit on the field, and everything was fine until everyone rushed the stage. I went right along with the crowd—a huge sea of people. My poor mother and brother were afraid I would be lost forever, but after a while I wandered back as if it were no big deal."

Southside resident Susan Choate Ridge, fifty-nine and a counselor and training consultant, was also in the audience. "I lived in Daytona at the time, and my best friend had two tickets to the Beatles concert, one for herself and one for her brother. When her brother didn't want to go, she asked me," Ridge says. "What I remember most was the weather. It was still very windy, and it was very damp. When Jackie DeShannon came out on the wooden platform at the north end of the Gator Bowl to sing 'What the World Needs Now,' her hair was whipping around her head. It kept covering her face, and I kept thinking it must have been difficult to sing that way."

Ridge also recounted another impression she had that night. "I have this strong image of being surrounded by people screaming their heads off. And I kept thinking, 'What in the world is possessing these people?' I was never a screamer. Still, I have to admit that at one time, it dawned on me that I was watching something pretty special when the Beatles finally came out on stage."

Many of the rest of us were still suffering from the ravages of Hurricane Dora. Most residents were without power for days. The streets were still littered with debris from the storm that hit near St. Augustine and made its way up Philips Highway past my house.

Thankfully, our house stood firm, but our yard was filled with tree limbs and windblown lawn furniture from another neighborhood. We had no power for a week, and the water we had stored in our bathtub had to be boiled on our barbecue grill until the all-clear came that the water lines were safe. Bathing was limited to sponge baths.

Personally, I was sick that my father would not allow me to go to the Beatles concert to be part of '60s cultural history. He was certain I would be killed either by downed power lines or rampaging Beatlemaniacs. So, I just had to sit home in the dark and dream about how wonderful it might have been.

E-mail responses to the column:

> good morning Dorothy. I just wanted to take a second and tell you how much I enjoyed your column today!
>
> thank you.
>
> jeff

<div align="center">* * *</div>

> I remember well the visit by the Beatles. All the young girls had "staked out" the most posh and expensive hotel in town, the Robert Meyer. My sister made me go with her and we were walking toward the Robert Meyer and were not quite there. We were at the moment in front of the George Washington Hotel, probably the second nicest hotel in Jax. But guess what? Yep, as luck would have it, a big black limo quickly pulled up and George, John, Paul and Ringo got out and were quickly hustled into a side door. I was within 10 feet of them.
>
> Bill Chapell

HERE'S TO THE WORK
OF A FEW TALENTED MEN—COACHES

September 27, 2008

I love the time of year when the sounds of football from the nearby high school come drifting through my open windows—whistles and groans, cheers and chants, band medleys and drills.

"Friday Night Lights" memories come alive for me then, and I am carried back to a time when one of the biggest social events of the week was the Friday night football game. Here we kids could meet our friends and hang out, whether we watched the game or not. We also could watch our boyfriends play, or we might even be the ones playing. No matter. I couldn't wait until Friday came with a pep rally scheduled for the end of the school day. After that, we were sufficiently fired up for the weekly ritual of football.

These memorable times would not have been possible, however, without the work of a few dedicated, talented men called coaches.

Northside resident Jimmie Johnson, seventy-three, retired Duval County School Board member and former principal of William M. Raines Senior High School, is one such man. He began his career as a football coach in 1957 at Northwestern Junior/Senior High. His most memorable player is Sam Davis, who went on to play in four Super Bowls with the Pittsburgh Steelers.

Many others in this community felt Johnson's powerful influence, too.

"It's wonderful to realize the impact that you had on these young men," Johnson said. "Just recently, I was in attendance at a funeral when I got to talk

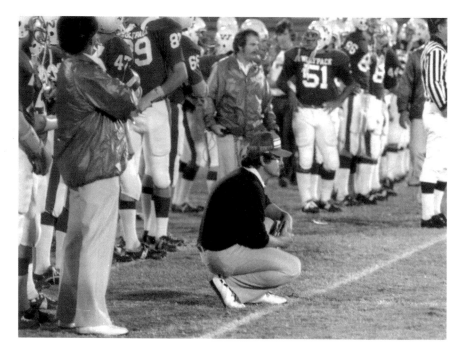

J.W. Seymore coaching from the sidelines in early '70s. *Courtesy of J.W. Seymore.*

with one of my former players afterward. We stood out in the sun for over an hour, telling stories and laughing about all the good times we shared."

One story was how Johnson prepared for the great rivalry between Raines and Stanton, "the granddaddy of them all," as he called it. "I came out in a red suit and red wide-brimmed hat. The crowd went wild. It didn't help our luck, though. By the end of the game, I was so upset that I slung the hat across the field and vowed never to wear that outfit again."

Beaches resident J.W. Seymore, sixty-six and a retired athletic director of Samuel W. Wolfson Senior High School, is another revered football coach. He coached for thirty-six years in Duval County after five years in another state.

His most memorable player was Jeff Rouzie, who had signed to play with Paul "Bear" Bryant at University of Alabama before Jeff suffered career-ending knee injuries in an automobile accident. Rouzie didn't let that injury stop his love of the game. He got his degree and then coached with Seymore at Wolfson for many years.

Seymore laughs out loud when he tells about how Assistant Coach Virgil Terry actually tackled an Englewood High School player during a

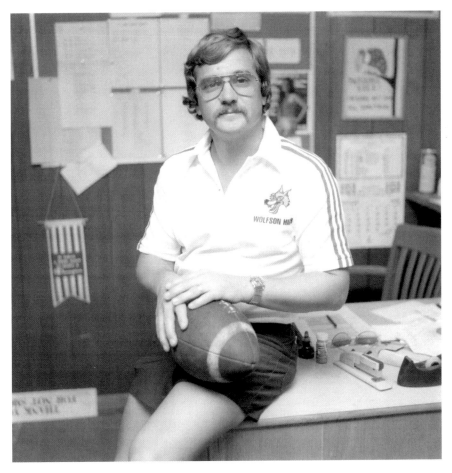

J.W. Seymore in the coaching office of Wolfson Senior High. *Courtesy of J.W. Seymore.*

Thanksgiving Day game in the Gator Bowl, where the rivalry was always contested. When Shorty Long, the official, came over and asked Terry why he would do such a thing, Terry responded, "He was going to score!"

Seymore has loved coaching because he could help many young men who faced incredible battles in their daily lives. "Athletics gave these young men something to hang on to, and it required that they meet high standards, which made them feel good about themselves."

What Seymore misses most about coaching is the camaraderie he shared with players, coaches and teaching colleagues. "The people I worked with were outstanding. We were all on the same page. We knew what the others were doing, and we could really help these kids together."

So it is no wonder that when the Florida Athletic Coaches Association has its annual barbecue, Johnson and Seymore are among the many fine coaches there. You can just imagine them laughing at football escapades and basking in the knowledge that they have made all the difference in the lives of so many.

POPULAR TV HOSTS INSTILLED VALUES, KEPT CHILDREN HAPPY

October 18, 2008

Once in a place called Jacksonville there lived two television personalities who provided quality programming for all the children.

The first was Ranger Hal, a forest ranger who would descend a fire tower each weekday morning to entertain us. The other was Skipper Ed, the captain of a studio boat who brought fun to our living rooms every afternoon.

Henry Baranek (aka Henry Baran) was Ranger Hal for a show of the same name that first aired in 1958 on WJXT TV-4. He had many adventures. From driving around Daytona Speedway with a ranger hat on top of his helmet to water skiing with bathing beauties at Cypress Gardens, Ranger Hal was always fun. He also provided "how-to" segments on crafts and *Crusader Rabbit* cartoons and had visiting audiences of nicely dressed children from the area.

Ivy Ludwig Eyrick, fifty-eight and retired production manager for Theatreworks, was once one of those smiling children in the studio. "I was shocked when I realized that Ranger Hal only came down the last three or so steps of a fake tower. On television, he appears to be coming down from a very high fire tower in the forest. So much for the magic. Still, I thought he was very handsome."

David Baranek, fifty and a defense contractor near Washington, knows all about Ranger Hal, his father, who died in 1979. "Our family is proud of our

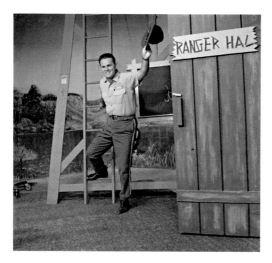

Ranger Hal coming down from a studio forest ranger tower in the late '50s. *Courtesy of David Baranek.*

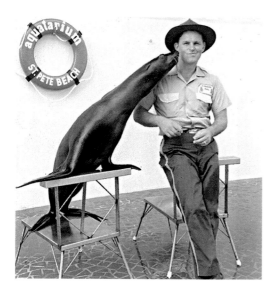

Ranger Hal getting kissed by a seal at St. Pete Beach Aquatarium in late '50s. *Courtesy of David Baranek.*

father's legacy. We've heard from so many who enjoyed seeing him on television," he said. "My mother has a letter from a man who told of an unpleasant childhood. Watching the show every morning was the only good part of his day."

Of course, the celebrity of Baranek's father had some drawbacks. "When I was six, our family moved to a new neighborhood, and one of the kids who lived there rode around the block yelling 'Ranger Hal just moved in!' We soon had ten kids at our house. It was, however, a good way to make friends."

Baranek admits, however, that there were some perks to being associated with such a popular TV personality. "He took us to the WJXT studios often, even when we weren't going to be on the show, and as you can imagine they had a lot of fascinating things and friendly people there. He also took us to almost all of his 'personal appearances'—when he went to the circus or to Marineland, to open a store or to ride in a parade. Sometimes we got to ride an elephant at the circus or a convertible in Ocala or downtown Jacksonville, and that was a great adventure. But

even when we just hung out in the crowd with all of the other kids, it was great to have the behind-the-scenes awareness that we had."

Baranek also expressed great pride in the legacy left by his father, Ranger Hal. "Over the years we heard from so many people who enjoyed seeing him on television when they were children. The website has refreshed those memories and hopefully helped many of these fans to relive their own memories. We also received the occasional letter or comment from someone who said Ranger Hal was their only friend, or helped them get through hard times."

"Skipper Ed" McCullers hosted two children's shows in Jacksonville. The first was called *Popeye & Pals*, which first aired in 1959, when TV-12 was WFGA. When TV-12 was WTLV, *The Skipper Ed Show* ran until the '80s. Both shows featured *Popeye the Sailor* cartoons and children from the community making up a live audience.

Arlington resident Meg McCullers Fisher, fifty-three, vice-president of the Clara White Mission, remembers fondly the years her father, who died in 1992, played host to Jacksonville's children. "I believe that he recognized right away that being Skipper Ed presented him with a real opportunity to instill values," she said. "The 'mind your manners' tagline on his show was a mantra with real meaning in the McCullers household."

Fisher did admit that it was not always easy to share her father with the kids of Jacksonville. "As a small child, I was always eager to have my own agenda addressed, but Dad would explain to me how important it was to be polite and to treat people with respect. I remember many times sitting to one side until the last autograph was signed."

But being the child of a celebrity had perks. "The 'first run' of *Skipper Ed* started in 1959 with *Popeye & Pals*, and lasted until I was a junior in high school (there was also a *Skipper Ed Show* in the 1980s), so I became forever known as 'Skipper Ed's daughter' in the first grade. I was always so proud of him, so that was a good thing. Even this past summer at my thirty-fifth high school reunion, I heard it over and over again…it was great!"

One of Fisher's funniest memories of her father concerns a public relations event the station ran with the circus:

> *Dad would ride an elephant down Adams Street, past Channel 12, as part of the traditional elephant parade Ringling Brothers did when they came to town.*
>
> *Don't know what got the elephant going, but she suddenly broke from the sedate pace of her trainer and charged off down Adams Street with Dad hanging on for dear life.*

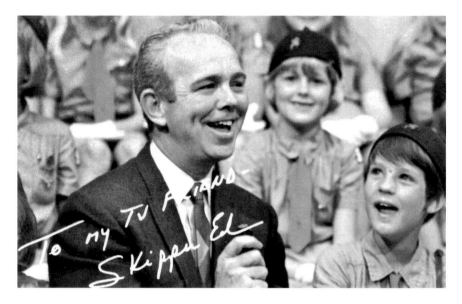

A close-up of Skipper Ed from the '60s. *Courtesy of Meg Fisher.*

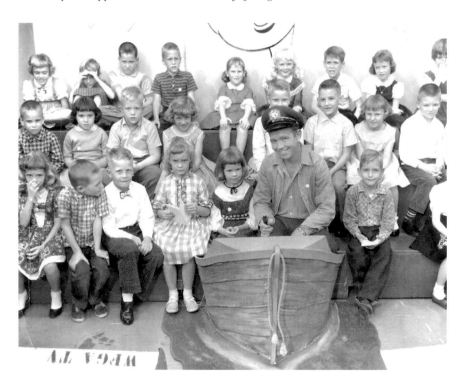

Skipper Ed with kids in a studio boat from the late '50s. *Courtesy of Meg Fisher.*

The trainer chased her down, and Skipper Ed—whose hat never came off—was safely removed. Dad expressed that any ride he had ever taken in a Blue Angel paled in comparison to the bolting elephant.

Both of these TV personalities may be from a distant, gentler time, but the upbeat messages they promoted made it so children around here could grow up to live happily ever after. How could it not be so with Skipper Ed there to remind us to "Mind your manners!" or Ranger Hal saying, "Be good, have a happy birthday, get well soon, listen to Mom and Dad—they're your best friends—and remember—it's great to be an American."

E-mail responses to the column:

I really enjoyed your newspaper article about the "Popular TV Hosts" that we had here in Jacksonville back in the late 50's. I was born in 1951 at the "old" St. Lukes Hospital here in Jax and have lived here all my life. I retired two years ago after 33 years as a Police Officer. Looking back on the flood of nostalgic memories that your article instilled in me, I can say that you were "right on target" about the fact that these shows imparted high moral values to its viewers. Thus, the people who hosted them, Ranger Hal and Skipper Ed, contributed greatly to my eventual career as a Police Officer. I can only imagine how many other young lives and minds were touched by these two beloved individuals and the world, or, at least Jacksonville is a better place because of them.

Sincerely,
Bill Chappell

* * *

Thanks so much for taking the time to forward this letter to me, Dorothy. It has made my day! Talking with you this week was a real pleasure. My best wishes to you and your family.

Sandy Baranek

MARINELAND WAS AN EXPERIENCE A KID COULD NEVER FORGET

November 22, 2008

Of all the elementary school experiences in Duval County, the best had to be the yearly field trip to Marineland, the "World's First Oceanarium" located just south of the St. Johns–Flagler County line. This aquatic destination was such a treat for us—not at the end of the universe, but far enough from classroom drudgery to let us really enjoy ourselves.

Thank goodness our teachers cared to do all the required paperwork to get us there. According to Westside resident Jeannette Bryant, fifty-two and bookkeeper at King's Trail Elementary, "A teacher, then as today, needed to fill out a packet of eleven forms two weeks in advance of the trip. Then, the principal had to review the packet and approve it."

Bryant says, "On the day of the trip, permission slips were filed, emergency numbers left, bus vouchers for drivers documented and students counted and checked onto the buses. Only then were they off to a safe, fun, educational field trip."

San Jose resident Valerie Jordan White, fifty-three and a retired elementary school teacher herself, remembers with great fondness her childhood trips to Marineland. Then, she was a student at South San Jose, the name of King's Trail before it was renamed in 1976. "I can still see that turquoise Marineland building and the big piece of coquina at the entrance. I remember my parents giving me spending money for tacky Florida souvenirs. I also remember my parents telling me not to buy the live turtles. Maybe it

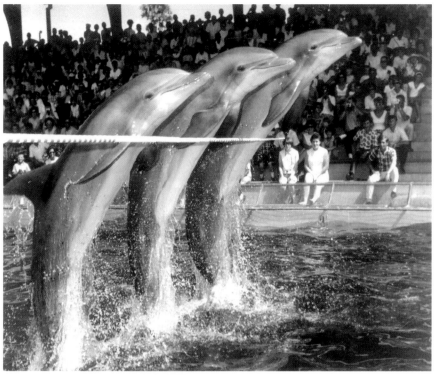

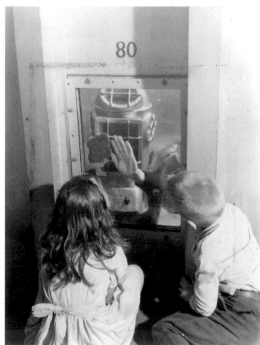

Above: Jumping porpoises at Marineland, 1971. *Courtesy of the Florida State Photographic Archives.*

Left: Children looking through a porthole at Marineland in 1948. *Courtesy of the Florida State Photographic Archives.*

The coquina gate that still stands at Marineland.

was alligator babies. I'm not sure, but we were not to bring home anything that breathed!"

According to Joan Whittemore, director of sales and marketing of the Dolphin Conservation Center at present-day Marineland, the site was originally called Marine Studios. It was opened in 1938 mostly for shooting underwater scenes. Some scenes from the *Tarzan* and *Revenge of the Creature* movies were filmed there. When Florida did not become a filming center, Marineland remained a tourist attraction.

After we kids of the '50s and '60s had watched through portholes as divers fed sharks and rays, we hurried to the show—bottle-nosed dolphins flying over hurdles or just high into the air. It was sheer joy to be drenched in the bleachers by a dolphin splash. We always cheered and dreamed that one day we could train dolphins.

Today, patrons can. Marineland is far more interactive. This facility was designed specifically for hands-on opportunities with dolphins and has earned accreditation from the Alliance of Marine Mammal Parks and Aquariums, an international organization of professionals in the field of marine mammal care and veterinary medicine.

There are no shows, but general admission spectators can watch through six- by ten-foot acrylic windows as others who pay for interactive programs feed, touch or swim with the dolphins. In the past, we little kids would have died for a chance to feed a dolphin, especially one like the original Jacksonville University mascot, Nellie, fifty-six. She is the oldest dolphin in human care and was there when we visited as kids. Today, she interacts with staff and the occasional lucky guest.

The Marineland field trip was our favorite. After the shows and sightseeing, we made it to the gift shop to buy souvenirs with our pocket money so we wouldn't forget our good time. For the record, though, no one at present-day Marineland recalls if any live animals were ever for sale in the gift shop.

E-mail responses to the column:

I'm not responding about Jacksonville recollections but just a fun postscript about Marineland. I FED THE DOLPHINS!! Sometime during the middle 1940's my husband's cousin worked at Marineland and arranged for me to be "part of the show." The girl who fed them ahead of me was a famous teen opera singer, Anna Marie Alberghetti, but that wasn't nearly as exciting for me as feeding the dolphins. This is by no means newsworthy but just to let you know there is someone around who has had the experience that you wrote about.

Sincerely,

Yvonne Paffe

BUILDING WITH COOL SAN MARCO LOFTS
WAS ONCE A SCHOOL

December 27, 2008

Southside Grammar, School Number 7, was already ancient when I attended seventh grade there in 1962. That was the year of the Cuban Missile Crisis, which took place just a few hundred miles from Jacksonville. My old school was as good a place as any to face the end of the world. Thankfully, however, world leaders resolved their differences, and we moved safely into posterity along with School Number 7.

From its dedication in October 1917 to its closing in 1971, School Number 7, located on Flagler Street in San Marco, served as either a public elementary school or a seventh-grade center in the Duval County School System. From 1971 to 2000, the building was used by the school district as administrative offices and storage; but in 2000, it was sold to become something totally different—a residential and professional complex called the Lofts.

Southside resident William Cesery Jr., fifty-six and president of William R. Cesery Enterprises, has a longstanding connection to the history of Jacksonville. His father was the developer and builder for whom Cesery Boulevard is named. His son continued in his footsteps by also becoming a developer, as well as the driving force that saved School Number 7 for a totally new purpose.

"It probably would have been cheaper if we had started our complex from scratch," Cesery said. "We had to put in all new electrical, plumbing, and air

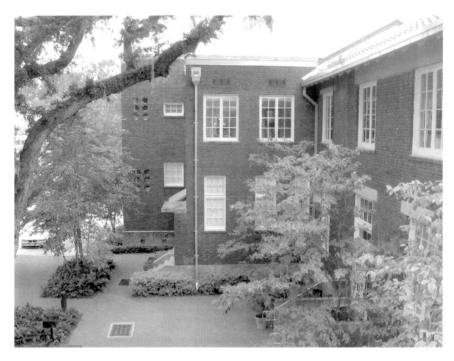

One of two courtyards at the Lofts, the renovated Southside Grammar School Number 7.

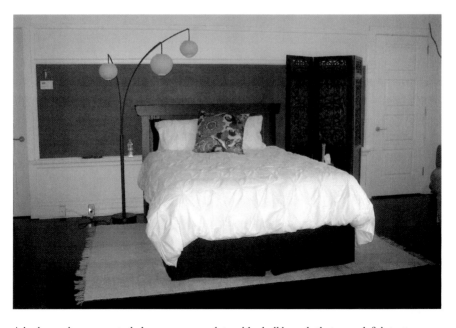

A bedroom in a converted classroom, complete with chalkboards that were left intact.

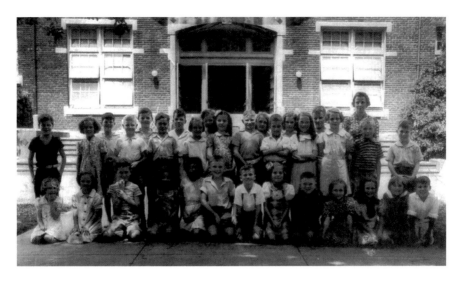

This is a third-grade class at Southside Grammar School Number 7 in 1938. Marvilene McCall Sage is seated in the front row and is third from the right. *Courtesy of Marvilene Sage.*

conditioning systems. We had floors to replace, and we had to redo several rooms on the first floor. And we had to get everything up to code—sprinkler systems, raise the railings, provide parking, put in a pool and gym. Then each room had to be outfitted with kitchen, bath, washers and dryers. And we had to do everything so we could still get our National Registry status."

Renee Parrish, forty-six and an account executive for Davines Hair Care Products, is a resident of the Lofts. She has a lovely apartment that was once a classroom. It even has a blackboard at one end where her bedroom is located. "I love how open and light my place is. I somehow feel really safe here, and I like that there's a mix of businesses and homes. This place is great."

And one doesn't have to live in the Lofts to be happy about its transformation. Southside resident Patricia Cascone, sixty-one and presently director of Development for Competitive Funding for the Duval County School System, worked for the school system as a test developer from 1981 to 1983 within the walls of School Number 7. She is thrilled that it has been remade. "Number 7 was the kind of place that encouraged you to roll up your sleeves and dig in. We sat at desks in big, open classrooms with high ceilings, plaster walls and tall windows that offered a view of the old San Marco neighborhood. We were encouraged by Number 7's comfortable shabbiness, by its safe old architecture—it felt like home to us, and it was the best place I have ever worked."

Now when anyone walks past the Lofts, they should not be surprised if they hear the echoes of children's laughter or the trudging sounds of reluctant students moving to classes. It's just part of history replaying itself in the minds of those who love these old buildings and who are happy to see that they get new leases on life.

E-mail responses to the column:

Hello Dottie.

A friend sent me your recent feature article about the old Southside Grammar, now The Lofts. You were a student there in 1962 in 7ᵗʰ grade? Me too. Although I had been there since 1956, and 62–63 was my last year in that great old building. Did we know one another? Did you go by another name then? You must have been part of the cadre who came to SS #7 for that one year and then went to Landon or DuPont. I was in the Landon group for two years until the new Wolfson opened. What a nice surprise it was to go from un-air conditioned grammar school and junior high to a brand spanking new high school with a/c and fresh paint.

Would love to hear from you.

Philip Smith

* * *

Forgive my long, long email messages. I've been away from Jax so long that I do get excited about making contact with someone who goes so far back in my life and memories of things that I, too, love. I hope you don't mind me asking so much and spilling over with enthusiasm for my dear old home town.

From the little I know about your career and talents, I think you'd get a big kick out of *Palmetto Leaves*. It focuses on Stowe's winter vacation base in Mandarin and has wonderful descriptions of life along the St. Johns. Her son had been with the U.S. army stationed in Jacksonville during the war, and he wanted to come back and live there. She purchased land for him across the river near Orange Park.

Going back another 100 years, have you read Bartram's travel stories about his explorations down the river? Dan Schafer set up a good website for his UNF students with photos and Bartram passages, see http://www.unf.edu/floridahistoryonline.

I really liked your Sally Martin HoJo feature. You must have kept in touch with her. Did you attend last summer's reunion? I'd intended to make it, but schedules wouldn't permit. Maybe it was for the best since I didn't lose the 20 pounds I'd intended to shed (see photo for proof).

You mention your church choir. Is it a Presbyterian church? Which one? Is it where you've attended since childhood? Do you still live near your childhood neighborhood? We lived on Peachtree Circle with our back yard bordering undeveloped Oaklawn Cemetery property. Now both my parents are buried in that cemetery. When I was in grammar school, we lived off Atlantic Boulevard on land that was taken by the approach highway to the then-new Hart Bridge. Our house was taken by the expressway authority, so we moved across the Southside to the nether regions between Miramar and Lakewood.

Please share your favorite books on Florida. Yes, I love Rawlings. Dad had a copy of her cook book, and we used it often. Harriet and I stopped by her home a few years ago while I was doing research in Gainesville. Did you drive through the little burg of Micanopy? Neat place. I first heard about it in a Bailey White story.

I'll be good and stop this before I ramble on too long.

Phil

* * *

[And here was my response:]

Dear Phil,

Love your photo. And I understand about that 20 pounds (or in my case more). I have had the bulge battle most of my life, and I think I am losing it right now. Oh, well. There will be other reunions. As for Sally Martin,

now Newkirk, her mother-in-law goes to my church, so I see Sally periodically. I asked for her help when I got the column and she, being a sweetheart, was very helpful. She lives in Atlanta now.

I still go to Lakewood Presbyterian Church on University Boulevard. I've been an elder there twice, and I love singing in the choir. We are headed to Ireland for our next singing tour. I lived on Marianna Road growing up, and Hardy and I lived on Fordham Circle for about 11 years when we were first married. Now I am on Ponce de Leon not 20 houses away from my childhood home. Mrs. Jennings, my gym teacher, still lives down the road from me. My parents are both buried in Oaklawn Cemetery so I have a pretty good idea of where you lived. Hardy lived on Sheridan Road and his neighborhood was split when the expressway came through. He was actually born here in Jax. I was born in Wisconsin. That makes me a transplant, no?

I am pretty busy helping my daughter now that our grandson has arrived, so I haven't read any books lately, but I'll get to Harriet's book eventually. Mandarin, where her home was, is so over-developed. I had at one time wanted to move out there, but the traffic is very bad. I am glad to be where I am.

Must sign off. I have dinner to finish and "miles to go before I sleep..."

* * *

Dottie

In our high school days, Mandarin was "out there" and not too developed. But it zoomed in the 70s with the [then] new bridge to Orange Park. Too bad that the old look and feel of Scott Mill Road is largely gone.

You know from reading Dan Schafer's book about Anna Kingsley that she once had a residence and farm somewhere near where the Buckman Bridge crosses. What a great archeological excavation site that would be if it could be found.

My dad used to know Joe Hammond who was from an old Mandarin family. Do you have that great book on

Jacksonville's architectural heritage? By Wayne Wood? Wowie, that is a wonderful resource. When my mother lived with us in Texas, she and I used to leaf through it and she'd stop and tell stories about this and that old house or building. I think the old Hammond home in Mandarin is in that book.

Lakewood Presbyterian—I know it well. Didn't a number of our classmates go there, too? A neighbor of ours went there, the Stokes. That's very nice that you're still a part of the same congregation from childhood. My old Jacksonville church is defunct. It was the Christian Science church at First and Laura Streets downtown. It's now the Karpeles Manuscript Library.

Dottie, I know you're busy, but I'd enjoy hearing from you about your writing projects.
Phil

DRIVE-INS WERE MORE
THAN JUST PLACES TO SEE MOVIES

January 24, 2009

The last time I went to a drive-in theatre, I was two weeks overdue with my first child. It was the mid-'70s, and my husband had come home and found me in tears. He took action by taking me to the Southside Drive-in. There we watched the monster movie *Godzilla vs. Megalon*, and that did the trick. I went into labor later that night and gave birth to my daughter the next day.

Many others in Jacksonville share warm feelings about the long-gone drive-in theatres of earlier generations: the Midway, the Atlantic, the University and the Southside. They were great fun for all ages. For children, they were magical places with playgrounds near the front and places in the back to buy popcorn and candy. For teens, they were great places to hang out with friends and to take dates. For adults, they were places to escape the mundane world by watching movies in the comfort of one's car.

Southside resident David Shrout, fifty-three and a longtime employee of Big Chief Tire Company, is one such person who misses his neighborhood drive-in—the Southside Drive-in, once at Philips Highway (U.S. 1) and University Boulevard. "When I was a teenager, we would often sneak in. There was just a small entrance on U.S. 1 and usually one person at the gate. My friend would drive in alone and two or three of us would be in the trunk."

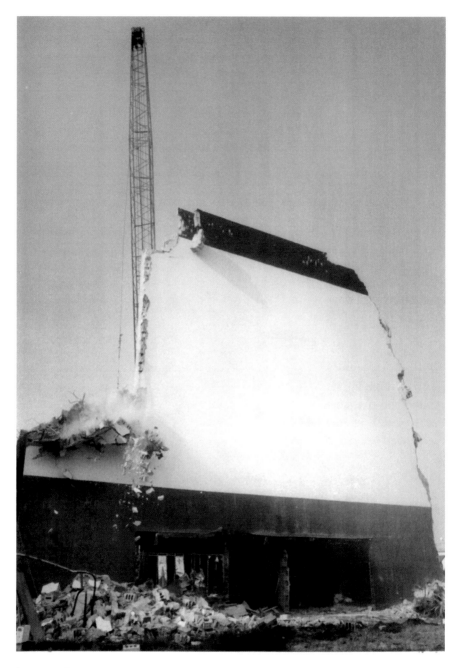

Southside Drive-in Theatre as it is being demolished in 1980. *Courtesy of the* Florida Times-Union.

A speaker that was salvaged from the Southside Drive-in by David Shrout. *Courtesy of David Shrout.*

Shrout recalls a concession stand in the middle of a hilly field and cars driving up on little mounds for good viewing. Speakers on stands looked like sentinels just about car window height.

Sadly, the culture changed. It became much less trouble to watch a movie on TV at home than to go to a drive-in to see one. As people stopped going, drive-in theatres slowly began to close. About 1980, they tore down the Southside.

"My boss at Big Chief, Steve Bennett, fifty-four, and I stood out back of our store as a giant crane with a wrecking ball parked on University Boulevard," Shrout said. "We watched the big ball swing and crash into the back of the screen and slowly demolish it down to rubble."

Before demolition, Shrout and Bennett got to go through the movie offices behind the tire store. They found movie posters and a mirror. In the old concession stand, they found a sign that said "Southside Drive In/Corner of Longwood Road and US1," a stainless steel Coca-Cola box that they still use at Big Chief and an old speaker.

It is hard for many of us to pass the corner where the Southside Drive-in once stood without feeling pangs of nostalgia. "People come in our store all the time and ask, 'Isn't this part of the old drive-in?' and we have to set them straight and say, 'No,'" Shrout said. "Our building was built in 1948 by Ripley Block Company, and it was originally a Standard Oil gas station."

Drive-ins, especially the Southside Drive-in, were great places to be kids, teens or expectant mothers. I am just sorry that my daughter and her children won't be able to endure the heat and the mosquitoes the way that we did in order to watch a movie there. It really was a blast!

E-mail responses to the column:

Dorothy,
Thanks for the great article on Drive In Movies. Really popular when I was a Teen back in the 50's and 60's. Of

course we used to do some of the things that you talked about and maybe a little more that we can't talk about (Remember we were boys).

But some of the Drive In's that we went to as kids are *still operating!* Well, at least 3 that I know about.

I came from Southwestern Pennsylvania in 1989, worked on CSX. But I fondly remember the concession stand's hot dogs, fries and popcorn. It seems to just taste better when you got it from those places.

In the early days, there would be a "car hop" girl that would come knocking on the window to take your food order.

Two of the Drive In's have expanded to two screens and one has a Sunday morning Flea Market. They are still popular even in the cold winters of Pennsylvania (You can rent a heater that plugs in to the cigarette lighter).

They show up-to-date films. So (like in the old days), if you didn't want to dress-up too much, just pile the family in the car and go to an outdoor movie. They still have so much per car admission. It was a great evening out and some members of the family went to sleep after 10 pm.

I remember my mother first taking me to the Evergreen Drive In at Mt Pleasant, PA and seeing Ma and Pa Kettle. Of course in those days they didn't have Ratings; they were for all members of the family.

Thanks for listening.

Just a few thoughts to share about my memories of one of the best times in our young lives.

Ron Enos

Mandarin

PS: Keep up the good work

* * *

My grandparents used to take my brother and I every Friday night. We go early and play on the swings in front of the screen.

Alma Porter

* * *

These are just some of the early memories I have of Jacksonville's past.

1. Going to the San Marco Theater on Saturday Morning's to watch Cartoons or Movie for 10 cents.
2. Mims Bakery in San Marco Shopping Center for a whipped cream covered Birthday or Wedding Cake or great Marzipan.
3. Lebs Bakery and Delicatessen across from the park in downtown.
4. The Reform Jewish Services held Friday night and Saturday morning in the basement of Cohen Bros. Department Store in May, 1948.
5. The RC Cola Bottling Co. and buying cases of soda for a Saturday or Sunday Picnic at the Mfg. Plant. Thanks Mrs. Buckner.
6. Driving through the Alfred I. DuPont Estates or cruising by its waterfront fortification on the St. Johns River.
7. Going to Orange Park to pick fresh citrus fruit and hunt for Spanish artifacts on the Old Spanish Trail.
8. Boating in Cedar and Browns Creek. Watching Gators and huge Turtles, or following Browns Creek all the way to Silver Springs.
9. Remembering the millions of Starlings creating more than a nuisance in the Downtown Park Area.
10. The Little Red School House in 1950, attended before and after by so many.
11. The building of the Prudential Building. Attending an evening performance of *Pussy in the Well* when my sister was the cat.

　If you want more of the past, let me know.
　Ian Jay Germaine

* * *

Dorothy, I've enjoyed reading your articles that Claire has been kind enough to post. I was born and raised

in Jax, but moved away in 1973. Your article on the Southside Drive-in was interesting. Spent more than a few Friday nights there and at others in the area. It's nice to see someone else has an interest in "the way we were." I look forward to another. Thanks.

William Spiers

* * *

Funny what we remember from our childhood, isn't it? My Daddy passed away nearly four years ago, but some of the best times I remember were the ones when just the two of us would go to the Atlantic Drive-In Theater. He would take me to see the horror movies I loved, and I would sit through the war movies and westerns he loved—a fair exchange I think.

Susan Garrison

* * *

Wow! The Southside Drive-in. When they built that we all thought we'd died & gone to heaven. A place to go! Sometimes Mama loaded us all up & off we went. Better still, a bunch of us would stop at the Burger King across the street, fill up the trunk with kids, drive over & pay for 2, park on the back row & out poured kids like clowns out of a clown car. Remember those horrible, sloppy, bar-b-q sandwiches they had? Loved them. The closest I've ever found to them is a bbq sandwich at Dairy Queen. Who has never driven away with the speaker still on the window?

Oh yeah. Remember wearing loafers so you could put dimes in the little flaps on the front. Theory was, if your date got really out of hand you'd take a dime & call your mom to come get you. I actually did that twice. Obviously, these were guys who didn't know my granddaddy was Chief of Police of Jax!

Cheryl Taylor

* * *

Oh the drive-in. We had this big ole hawking station wagon. Our parents would construct a pallet in the back with quilts and lots of pillows and then back into the spot. Open the top and we would lay there in the lap of luxury watching the movie. Don't know about y'all, but I miss drive-ins.
Marty Martin

PHARMACY SODA FOUNTAINS
BRING BACK MEMORIES

February 21, 2009

E ven though we love progress, it is bittersweet to watch as treasured
institutions give way to new ones. At no place is this more evident than
the corner of San Jose and University Boulevards.

In December 2005, an eating establishment called Tijuana Flats moved
into the space that once housed the Lakewood Pharmacy.

Lakewood Pharmacy was the crown jewel of the shopping center, which
opened in 1948, according to an article in the *Florida Times-Union* on August
29, 1990. The pharmacy had a soda fountain, a drugstore with home
delivery, a lending library and gifts.

No part of the old pharmacy was more beloved than the soda fountain
in the back. The luncheonette was a "meet and greet" place where people
could buy breakfast, lunch or sodas, as well as ice cream until the early '90s,
when the pharmacy was downsized.

Southsider E.J. Ojier, a certified property manager for the Colonial
Properties Trust, manages store properties in the Lakewood Shopping
Center and remembers enjoying the soda fountain in Lakewood when she
was little. "It had stools that twirled, checkerboard floor tiles and sodas and
cherry Cokes. There was also a town hall feeling to the place. People tended
to gather there."

Kris Barnes of San Marco, fifty-four and a former Duval County School
Board member, also remembers Lakewood's soda fountain with great

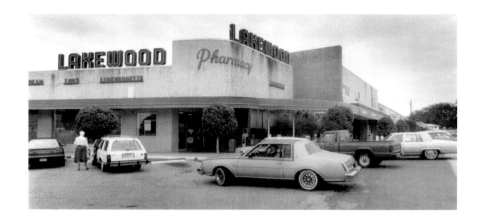

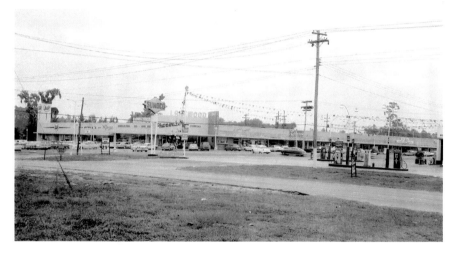

Top: Lakewood Pharmacy in 1990. *Courtesy of the* Florida Times-Union.

Bottom: The corner of San Jose Boulevard and Longwood Road, now University Boulevard, in 1956. *Courtesy of the Florida State Photographic Archives.*

fondness. "As a child, my mother would take me there, especially after I got my shots at Dr. Kelly's office down the road. I'd soon forget my hurt as I'd spin myself on the chrome seats with green vinyl tops."

Later, when she had her own children, Barnes would take them there at least once a week. "We mothers would sit at the tables and socialize while our children sat at the counter enjoying good meals, like grilled cheese sandwiches or handmade burgers served with vegetables."

Gail Grossman Baker, sixty-seven and director of Child's Play Preschool at Lakewood Presbyterian Church just up the road from the

pharmacy, worked for pharmacist Mr. John Greenall while she was in high school. Greenall and pharmacist Walter Griffin were co-owners of a small local chain of pharmacies—two in Riverside, one in Lakewood, one in Mandarin and one in the Prudential Building. Baker also worked with two other pharmacists in the Lakewood store: "Doc" Fulmer and Jim Watts.

Baker mostly worked the register at the cigar counter near the front door, but occasionally she got to work in the cosmetics area for Irene Thomas, who headed that department. Baker also got her turn to work the soda fountain with a woman known only as Gussie, who did all the short-order cooking behind the scenes in the kitchen.

Of her years working at Lakewood Pharmacy, Baker had this to say: "It was such a good time. It was my little neighborhood, and I see people all the time whose children and grandchildren I am now teaching at my school."

Of course, Jacksonville had many other fine soda fountains, mostly in the rears of drugstores. My husband's favorite was in Preston's Drugstore on the Southside. There, he often ordered the "Patrol Boy Special," a cup of shaved ice with water. My cotillion buddies and I went after dances to Norman's Pharmacy in Miramar to enjoy the famous "frozen Cokes."

Tom Tankersly of Mandarin, sixty-five and retired general director of Special Programs for the Duval County School System, remembers going to his own Murray Hill neighborhood soda fountain at Small's Pharmacy at Edgewood Avenue and Post Street. "Small's was an old-time drugstore. The floor had tiny hexagonal white tiles, and through the years so many people passed through that the tiles were worn down. Behind the counter of the soda fountain, a huge mahogany frame went around a giant mirror. Hunter fans spun slowly above, moving the summer air. We kids spun around on the stools waiting for our sodas, sundaes and, our special favorite, banana splits. Sometimes even old Mr. Small served us himself."

The kinder, gentler time of little drugstores and their soda fountains has mostly faded from present-day experience; that part is bitter. Many of us are lucky, though. We can remember our good times at soda fountains in places such as Lakewood or Small's Pharmacy.

Our memories of those times and places cannot be replaced, and that, like the sodas and ice cream, is sweet.

E-mail responses to the column:

Dear Dottie,

I just wanted you to know that I greatly appreciated and enjoyed today's article about the Lakewood Pharmacy. I used to hang-out there as a kid. The photo and your article really brought back good memories. Thanks for bringing it all back. Is it possible for you to e-mail me that photo of the pharmacy? I would love to have it for my memoirs.

Thanks for a job well done!

Sincerely,

Hal

* * *

Enjoyed your article in Sat's My Community. Sometime when you are in the Ortega area stop in Carters Pharmacy and check out their soda fountain. It has a gourmet chef in white jacket & all. Great food too.

Catherine Brantley

* * *

Dear Dorothy Fletcher:

Thanks for the great article about the Lakewood Pharmacy.

My family moved to Jacksonville in 1949 and lived on the north side until 1950. We moved to Lakewood and lived in the Lakewood Apartments until 1954 when dad bought our house on Emory Circle.

So many memories.

The shopping center where Winn Dixie is was only woods. No shopping!!

Please keep up your history of the Lakewood area even with its 2 lane high crown roads.

Larry Boon

* * *

Dear Dottie,

I did see your story about the Pharmacy and of course loved it. It was the only place where I could make a private phone call to my boyfriends (yes, I called boys) using the phone booths located in the restaurant. I do remember frequenting the lunch counter with Beverly Fetter ordering only french fries and a cherry coke. I remember it well. I also remember the beauty counter there that sold Ambush and Intimate by Revlon. I did a lot of Xmas shopping there.

By the way, have you seen the website for the Landon High School Class of '56??

Check it out for the pictures...http://www.landon56.com/MemoryLane.html

Claire

* * *

Hello!

I am a Jacksonville native that lives in Northeast Georgia nowadays but comes back to Jacksonville a couple times a year where we have a townhouse in Mandarin. I enjoyed reading your article on Lakewood Pharmacy, and it brought back many memories of my childhood and later my dad meeting his cronies there for breakfast or coffee several times a week.

Another memory that surfaced was the wonderful little train at the corner of Mandarin Road and SR 13 which I had the pleasure of riding many times as well as taking my son to ride on Sunday afternoons and buying a bag of fresh popped popcorn to eat while riding through the woods and watching the farm animals that roam through them. It was truly a bittersweet day when the train stopped running and the property was sold for the shopping center that now is anchored by Publix and the gas station.

Keep writing these wonderful stories so others can relive their memories, too.

Nelle Walker
Hartwell, Ga.

* * *

Hi Dorothy,

Your article last month reminded me of what I enjoyed so much about our neighborhood drugstore. Like your husband, Preston's was "our" drugstore. Probably what I loved most about it was spinning around on the barstools (red, I think), and looking at my reflection in the middle of bunches of bananas and the Hobart (or was it a Hamilton) machine. My favorite treat was a strawberry soda with ice cream and soda water. I remember going to Preston's when a hurricane had come through, and we had no power at the house. Because the grill was gas, they could cook us a hot breakfast. I have lived in Jacksonville all my 57 years, and think we could use more places like Preston's.

Those old memories caused me to recall the days my family spent at the original Strickland's restaurant in Mayport. The Mayport I remember was different from the one today. It was even less busy than it is now, and there was no gambling. Just the fishing boats, the restaurants, the ferry and a small neighborhood. Eating at Strickland's was a big deal for my sister and me. I could not have been more than ten at the time. And no matter how many times that ferry came and went, my sister and I always craned our necks to see it and announced each arrival and departure.

One place I remember too was Harry Blitches' restaurant on Beach Boulevard (I think) near the Intracoastal. It was an unassuming framed house with wood floors and a dirt parking lot. They had the absolute best deviled crabs. Ask your husband if he remembers it—I've not found anyone who does. There was also a Borden's ice cream shop for awhile across from the Preston's store and my all time favorite place was Uncle Joe's (foot-long hot dogs wrapped in wax paper and homemade fries, delivered to your window on a tray) just across the street from the old Atlantic Drive In. Oh, such fun memories.

I look forward to looking back with your wonderful articles and I know many "natives" will enjoy them too. Thank you for the memories.

Susan Garrison

* * *

Lakewood Pharmacy? I had my first charge account privileges there. I was about 9, maybe 10, years old. I remember once charging too much on the account, and my parents made me take the purchases back for a credit: my first experience with merchandise returns. I was so embarrassed, but my parents were right. I was learning about responsible credit purchases and didn't even know it.

At the fountain area, they actually mixed the Coke syrup and soda to make our drinks, and they had the best hot fudge sundaes in the world!

I recall once sneaking out of services at the Lakewood Presbyterian Church, walking to the pharmacy for a sundae, and getting back before Reverend Benz let church out. Good memories.

Thanks for remembering an important and happy part of my childhood.

Sallie Streett Skipper
Tampa Bay Area

* * *

Been forever since I have been to Jax. and have been told I would not recognize it. But I loved it back in the day...always seemed like a big ole country town. Guess now it is a big ole metropolitan town. Progress...oh well.

I used to ride my bike to the Lakewood Pharmacy, from San Jose BLVD. Nobody ever worried about me being snatched or felt like they needed to put a GPS on me. We came in when it got dark, and I don't think mom and daddy actually knew where we were most of the time. Change ain't always a good thing.

Marty Martin

* * *

Those of us growing up in Fruit Cove & Mandarin back in the 50's had very little of what most considered "teen" entertainment. But, FINALLY, we had what we thought the rest of the world had—our very own drugstore on the corner of State Rd. #13 and Loretto Road. A jukebox!! Tiny dance area!! Soda Fountain!! Cherry cokes!! And don't forget, girls, the "drugstore cowboys" leaning against the wall outside. Be still, my heart.

Cheryl Taylor

GOOD, SAFE FUN

Collecting Soda Bottles and Trading for Cash

March 28, 2009

When Jacksonville was more rural landscapes than sidewalks and buildings, children had many ways to fill non-school hours. On weekends and over summer vacation, they would get on their bikes at dawn, and as long as they were back home before the porch lights came on, parents never seemed to worry.

Of course, not all activities would meet with parental approval—such as chasing cows or flattening pennies on the railroad track. There was one safe activity that Southside resident Elisabeth Crews, fifty-two and senior property manager for EastGroup Properties, fondly remembers. It was collecting soda bottles to trade for cold hard cash. She and her friends used their bicycle baskets to hold the bottles they found along Old Kings Road. They were headed for Paks Minute Market, which is now Bunny's Beverage. Like little merchants, the children bartered with the store clerk for the maximum money for bottle returns to buy candy.

"If we were lucky, all bottles were acceptable and we got upwards of twenty-five cents. Regular bottles went for two, and quart-sized bottles for five. We did leave some bottles on the roadside, though. They usually had something living in them or were beer bottles and worthless."

Once the money was appropriately divided, the kids made a beeline for the candy shelves. Along with the usual jaw breakers, Fireballs and Double Bubble Bubble Gum, there were Mary Jane's, BB Bats, Peanut Butter Logs

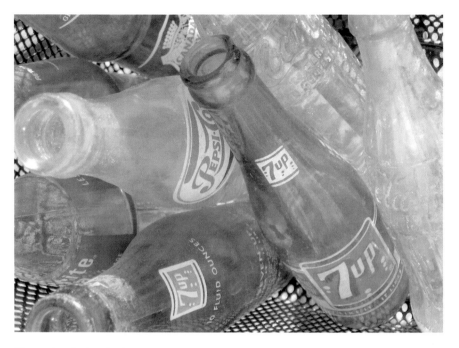

Vintage bottles in a basket.

and assortments of Sugar Daddies, Mamas and Babies. Add to that candy cigarettes, bubble gum cigars, wax lips and the little wax bottles filled with a sweet syrupy drink, and they were in heaven. "I remember that the store had a moveable glass wall they pulled back during the day, so it was really hot inside," Crews said. "That made us careful about buying chocolate, because it often was melted onto the wrapper."

Westside resident Susie Ross, sixty-seven and a registered nurse for Children's Medical Services, tells a more grown-up story about soda bottles. She would accompany her sons Jimmy and Steven as they rode bikes down Old Middleburg Road or Normandy Boulevard. She had learned the value of soda bottles as she grew up in Virginia, so it was only natural she would share this wisdom with her sons. "I was trying to help my boys find something to do when they were bored one summer, so we went searching the roadsides for bottles. After that, we'd take them home and clean them because we could trade them in for money at the Pic 'N' Save, Pantry Pride or Winn-Dixie."

All this talk about bottles and candy got me wondering if one could find such treasures anymore. I eventually found vintage soda bottles at Fans & Stoves Antique Mall in Five Points.

Left: A bottle bottom showing place of manufacture—Live Oak.

Below: Fans & Stoves at Five Points, once a Winn-Dixie grocery store.

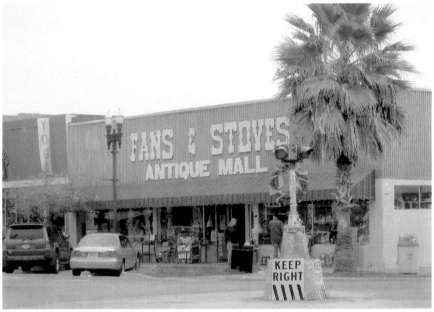

Riverside resident Ruben Escajeda Jr., thirty-six and owner and buyer, helped me find an assortment of old bottles—Cokes, Canada Dry, Diet Rites and 7 Ups. Most are now worth about six dollars each. As an interesting coincidence, my husband actually worked at this location when Fans & Stoves was a Winn-Dixie store.

Hardy Fletcher, sixty and retired teacher and school administrator for the Duval County School System, worked in Winn-Dixie grocery stores on a part-time basis for about five years. He even had "bottle room" duty, an odious assignment for which he had to clean, sort and stack in wooden crates

empty glass cola bottles to be returned to the appropriate companies—Pepsi, Coca-Cola, Nehi, Hires, Canada Dry, 7 Up, RC Cola and Grapette.

No one was happier at the advent of the no return bottle than I was. When I had the bottle room, I had to decide if I should do a good job so they would ask me to do it again, or if I should do a so-so job so they wouldn't…Having the bottle room meant no tips for the day because I wouldn't have the chance to take out groceries for customers. A big tip was a quarter in those days and I could make up to about twelve or thirteen dollars. That was enough for me to buy two Gant shirts, and it was almost enough to buy a seventeen-dollar pair of Weejun Loafers. No, I didn't like having bottle room duty. It was not profitable.

As for penny candy, well, that is a thing of the past. I found a pretty good selection of candy at the Gate Station on San Jose near Emerson, but what once was twenty-five cents' worth of candy cost me almost three dollars. Still, I could make myself sick with the candy I could buy, if I could just find one old bottle to sell.

E-mail responses to the column:

Hello Dottie,
 Are U into bottle collecting. I have some bottles…if you are interested. Send me a reply to this address. Thanks.
 Bailey

* * *

Thanks for sharing this one. I lived behind the Pizza Hut and Bonded Pools on Beach Boulevard and spent my summers and weekends in the Dempsey Dumpsters hoping to land those big 50 cents bottles! Then, I'd walk to the corner gas station and buy Double Bubble Gum and all kinds of rot-your-teeth candy! Those were the good ole' days, for sure!

Dr. Dana Thomas
Dean of Liberal Arts and Sciences
Florida State College at Jacksonville
North Campus

* * *

I collected pop bottles from the beach—down by the access when they were the accesses open to the public... we would cash them in for gas money so we could ride around Jax Beach Friday and Saturday night in my '54 Chevy Belair. Good times!!!!!!
 Patricia Weaver

WAPE PROVIDED SOUNDTRACK
FOR GROWING UP IN JACKSONVILLE

April 25, 2009

On May 13, 1958, the *Florida Times-Union* ran a story announcing the construction of a twenty-five-thousand-watt radio station about one mile south of Orange Park beside Moccasin Slough. The call letters were to be WAPE, and it was going to be the most powerful local station of the time. The Mighty 690, celebrating its fiftieth anniversary this year, stands out clearly in the memory of many Jacksonville adults. WAPE made us part of a larger world by introducing us to Elvis, the Four Seasons, the Beatles and the Supremes. It promoted local bands like Mouse & the Boys and the Soul Searchers. It was with us as we went to sleep and when we woke up and dressed for school. It surrounded us in the car wherever we went, and the music it played, along with its Tarzan yell, became the soundtrack of our adolescence.

"WAPE was absolutely the station we all listened to most, although we occasionally tuned in to Mike Ranieri and Chuck Dent on WPDQ," said Beverly Fetter Ewbanks of Tallahassee, fifty-nine and retired state unemployment customer service representative. "But the Big Ape was the station I had my radio tuned to most."

I think most of us would have to agree. Even though I have vivid recollections of WPDQ and the hilarious "shtick" of Chuck and Mike and their "Bertha Bread Sacker" dialogues, WAPE was the predominant station on my radio dial for my radio listening.

690 KC

WAPE logos used in '50s and '60s. *Courtesy WAPE.*

John Ferree, sixty-seven, who now lives with his wife on sixty-eight acres in rural North Carolina, was a disc jockey for WAPE from 1967 to 1971. "Honest John," his on-air name, broadcast his show on weekday afternoons from 3:00 to 7:00 p.m. and Sunday afternoons from noon to 6:00 p.m.

"The call letters [WAPE] are now owned by Cox Radio and are assigned to an FM frequency," Ferree said. "The frequency [690 AM] now has different call letters…so the old station is gone. Even so, it was a fifty-thousand-watt rock 'n' roll giant by the '60s—usually number one in Jacksonville and often rated among the top two or three stations in Daytona, Savannah, Charleston and all the other towns between Cape Canaveral and Cape Hatteras."

During his time in radio, Ferree witnessed many historical events. "Both Robert Kennedy and Dr. [Martin Luther] King were shot while I was at WAPE. We learned of Dr. King's death while I was doing a charity basketball game at one of the high schools…It was the time of the Vietnam War and the civil rights movement. There were riots in the streets. Large sections of major cities were being burned. The women's movement was getting started. Lots of history was happening all the time. That was what made my time there so interesting."

Ferree believes that the '60s youth culture "came about because of the big clear-channel radio stations of the '50s. The clear-channel stations were those few AM frequencies that the government, via the Federal Communications Commission, set aside for emergency communications. They were allowed to transmit with huge power and no interference at night. You could hear them for hundreds of miles."

And we kids in Jacksonville were listening. Whether lonesome songs like "For What It's Worth" by Buffalo Springfield or scandalous ones like "Satisfaction" by the Rolling Stones, all came through on our radios, loud and clear. So much so that my dad would often stick his head through my bedroom door and ask, "You call that music?"

And my reply was always, "Yes, Dad, I do.

E-mail responses to the column:

Hadyourphil: When I was growing up in Virginia and an avid radio listener, (commonly referred to as a "DX'er") I would catch WAPE as it was signing off. Before they received their full time license, they would sign off at sundown with that glorious ape call! Little did I know that I would end up working at The BIG APE in 1978! Fun, fun, fun! And being a broadcast engineer as well, I was fascinated by the home-made transmitters constructed by the late Bill Brennan. Awesome powerhouses. Just like WAPE!! Have a happy!

* * *

Loved the story when I read it this morning! Brought back memories of WOMP radio for me! Hadn't thought about that station in years...Thanks!
Terry Lucaralli

* * *

OH, I loved WAPE. I can hear the Tarzan yell now. I could hear it in Claxton on a clear night, but listened from Jekyll all the time.
Joyce

* * *

Good one! (Yet another good one!) In my memory, WAPE was more hard core rock n' roll and edgy where as WPDQ was slightly less threatening to adults. I suppose the two stations' reputations were carefully managed. Dad liked to have WPDQ on in the mornings. I remember hearing "The 59th Street Bridge Song (Feelin' Groovy)," the Harpers Bizarre version, and the song "Sukiyaki," and Horst Jankowksi's "A Walk in the Black Forest" on WPDQ while getting dressed for school. They played

popular but soft songs on WPDQ but stayed away from the Rolling Stones and The Animals. I think they played Beatles songs.

WPDQ studios were in the old Atlantic Coastline Building. Once I walked there after school at Landon and went to the studio. The public could stand behind a glass area and watch the DJ. I was thrilled to see Mike Ranieri but stunned to see how old he was. He was probably in his 30s, but I had thought of him as much younger.

The music of our generation seemed quite powerful, but I suppose it's been so ever since the birth of radio. Do you remember when you heard Bob Dylan for the first time? His voice repelled me, but something about the delivery also attracted me. I was not good at listening to the lyrics but mostly I liked songs for their rhythms and melodies, and I'd only catch a few words of the lyrics here and there. "The House of the Rising Sun" is a good example. Haunting and brooding and serious sounding, but can't say that I really paid attention to the lyrics. Now when I listen to Dylan songs, wow!

Back when the invasion of Iraq began our local community radio station played two straight hours of 60s era anti-war songs. I had to go over to the station and get the playlist. It was powerful to hear all those old songs all in a row. I was very moved.
Phil

* * *

Thanks for the link, Dottie—and congratulations on your columns. Did you know that Pat Conroy mentioned WAPE in his novel, *The Great Santini?* Apparently, when Conroy's dad was stationed in South Carolina, teens could pick up WAPE, so it must have been a powerhouse station!

Pat B.

* * *

[Submitted by Scarlet on Sat. 4/25/2009 at 12:46 pm]

As a child and teenager, I was crazy about WAPE-AM. They had great concerts where they brought in multiple acts...The Four Seasons, Lou Christie, The Beach Boys, Gary Lewis and the Playboys...and, many many more. All of these groups would have their turn playing on the stage in the Jacksonville Coliseum. And, if my memory serves me correctly, we only paid around $4.00! The Brennan brothers, who were the original owners of WAPE-AM, did so much with their radio station. They made sure the DJs were out and about meeting the listeners. And, because the signal was up and down the coast, I think those DJs were in Myrtle Beach, SC almost as much as they were in Jacksonville.

And, let's not forget the Beatles! The Brennans brought the Beatles to town on the weekend after Hurricane Dora struck the area. But, there was still a huge crowd and people are still talking about that event to this day.

There are just so many wonderful memories...Honest John and Jim Shirah and Alan Sands were always partying when it was their turn to spin the hits.

Thank you, Dorothy for such a nice article. And, thanks to all of the people who made The Mighty 690—WAPE AM the incredible station that it was.

Mary Jo Trenkler
"Scarlet's Rhymes" at Jacksonville.com

* * *

The AM station of the beaches too...it was great and we listened to the top 40 every weekend at the ocean—car radios all played the same station—The Big Ape!!!!!!!
Patricia Weaver

COLD WAR HAD IMPACT ON
CHILDREN OF THE 1950S AND 1960S

May 30, 2009

When my father died, I found in his personal items a single dog tag that I used to wear in elementary school. I was touched that my father had saved it, but as I handled the little piece of metal, I was flooded with ambivalent feelings.

During the late '50s and early '60s, when I wore this dog tag, the Cold War was a shadow that fell over our lives. At school, we watched *Duck and Cover*, a short film produced by Archer Productions in cooperation with the Astoria and New York Public Schools. It was designed to show children how to survive a nuclear blast. We also had evacuation drills, during which our mothers would drive us around the block to see how long it would take to clear the building and be on the road to Hastings.

San Jose resident Ivy Ludwig Eyrick, fifty-nine and retired program director of Theatreworks, remembers those years. "I was a student at San Jose Elementary and I recall how scary those evacuation drills were. Especially the 'duck and cover' stuff where you had to crawl under your desk...I also remember how we at my house were into rationing. I remember looking into an open closet and seeing all those cans and meals ready in case there was a bomb."

And the rest of the city was always at the ready for the worst-case scenario. On December 13, 1959, the *Times-Union* ran an article about twenty-four civil defense sirens being set up throughout the city. They would sound at

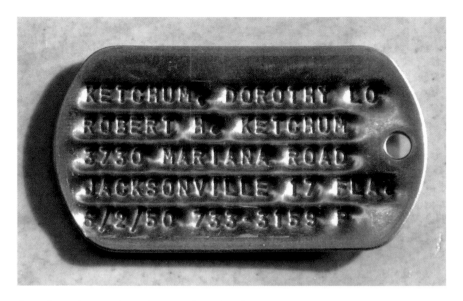

One of two dog tags the author wore in the late '50s.

noon on the last Friday of each month. This was to be sure that they were in working order in case of enemy attack. I remember stopping mid-game and waiting to see if the wail were a test or the real thing.

Adults drilled as well. On April 29, 1961, the *Times-Union* ran an article about "the eighth annual nationwide civil defense exercises" conducted in Jacksonville. We were "theoretically slammed by two multi-megaton bombs at 6:46 p.m. One of the H-bombs hit Mayport, and the other hit Cecil Field Naval Air Station."

And then there were these dog tags around our necks. Dr. Philip M. Smith, fifty-nine, professor of history at Texas A&M and former resident of the Southside, said:

> *I talk about our grammar school dog tags in my class lectures when we get to the cold war…I have a couple of distinct memories. We were asked to designate our religion, and each tag was stamped with a P, C, or J for Protestant, Catholic or Jewish.*
>
> *The chain was the main attraction. I remember twirling the chain on my finger. What I tell my classes today, however, is that the dog tags were part of the county's civil defense planning, and the purpose of the tags was the same as the military's use, that is, for "graves registration." How macabre that those tags, that were a source of delight and curiosity*

Above: Civil defense meeting in Jacksonville in 1961. *Courtesy of the Florida State Photographic Archives.*

Left: A civil defense siren. *Courtesy of the* Florida Times-Union.

for us, were in fact produced for a truly grim purpose. And I assume our parents knew the reason.

Atlantic Beach resident Elliott Ettlinger, fifty-eight and a retired plumbing contractor, remembers those "dog tag days" when he was at South San Jose Elementary. "The silliness of it all overwhelms me. The idea of dropping all of Jacksonville's elementary students in the potato fields of Hastings is absolutely ludicrous. Then what was supposed to happen?"

Dr. Smith finally put it all into perspective. "The bookend memory to those times is a very sweet memory. When the Berlin Wall came down and as the USSR fell apart, I remember a visceral feeling of relief that there would be no nuclear holocaust. It was a weight off my mind that I didn't realize was there until it was gone."

Surely, every generation has its monsters to confront, but hopefully our grandchildren will not dream of nuclear annihilation, and they won't have to wear dog tags.

E-mail responses to the column:

I remember the duck and cover from when I was a sixth grader in El Monte, CA, for two months while my parents thought we were going to live there (they hated it and we moved back to IL). I can remember practicing getting under my desk.

Linda Allen, Lakewood resident

COHEN BROTHERS WAS THE CENTER OF DOWNTOWN JACKSONVILLE

June 27, 2009

When visiting downtown Jacksonville, it is hard not to notice the building that has dominated the scene for decades—the Big Store, or as many of us knew it, the Cohen Brothers Department Store.

The building, which now serves as our city hall, was designed by Henry John Klutho, who had been commissioned by brothers Morris and Jacob Cohen. Their store opened in 1912 on the site of the St. James Hotel, which had burned down in the Great Fire of 1901. Anyone who grew up in Jacksonville almost certainly did some business at Cohens.

In the '50s, I thought it a special treat to dress up in Sunday clothes and go downtown to see Daddy at his work. It always meant lunch and shopping at Cohens. My father worked for U.S.F. & G. Insurance, located in what is now the vacant Physician's Building across the street from city hall. After an audience with the boss, my family would hold hands as we crossed Hogan Street to enter what I thought was one of the most magical places in town—Cohens.

Immediately, the smell of chocolates at the candy counter enveloped us—like chocolate-covered strawberries or the milk chocolate Annaclairs. As we moved along, we seemed to swirl through clouds of perfume in the delightfully cooled air. When at last we made it to the small café in the northwest corner, we feasted on sandwiches at little tables hardly big enough to accommodate our family of five.

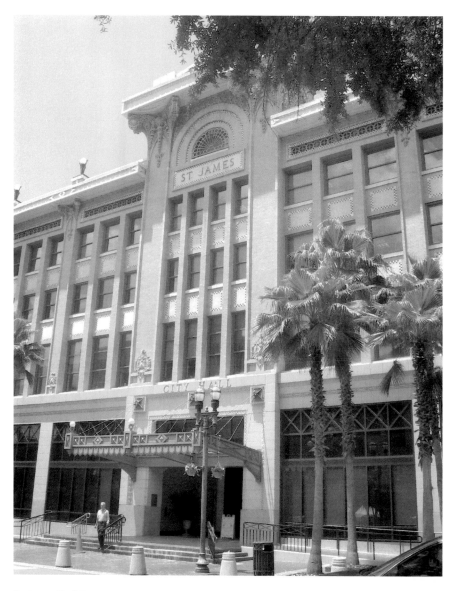

St. James Building, once the Cohen Brothers Department Store and now the city hall for Jacksonville.

In 1971, San Marco resident Rita Vaughn Kelly, fifty-nine and small business owner, was an assistant buyer for May Cohens, as the store was then called. Kelly remembers that at the time downtown was quite a happening place, with Cohens at the center. "First floor was men's clothing and shoes.

The lobby of Jacksonville's city hall. *Courtesy of Beckie Leone.*

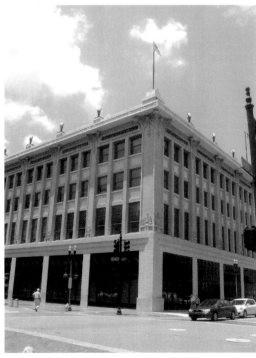

Another view of the city hall of Jacksonville.

The second floor was women's and children's clothing and the third floor was furniture. Most of the fourth floor was offices, but there was a candy kitchen there where many of the store candies were made. There was also a mezzanine where books, linens and fabrics were sold, and don't forget the basement with discounted items."

There was an escalator in the center of the store in those days and an elevator in which Kelly was once trapped between floors. "At the time, it wasn't all that funny," she said, "but now, I have to laugh. The two of us inside the elevator kept pushing the emergency button, not realizing that it was setting off a loud bell throughout the store. When the doors were finally opened, a huge crowd had gathered, and we were a bit embarrassed."

In the early '80s, I wanted my two children to have the Cohens experience. We would take the bus and get off at Hemming Park. We would enter the store, wander the aisles, eat hot dogs at the lunchroom and always buy a small bag of chocolates before catching the bus back home.

Every time I visit downtown now, I am drawn to the St. James Building, where Cohens was once located. I almost always go in and stand under the magnificent skylight of the renovated city hall. I can almost hear the escalator humming and imagine the shoppers milling about, and I am thankful and proud that the city fathers saw fit to preserve such an integral part of our history.

E-mail responses to the column:

> Dear Dorothy,
> I loved it! I'm so glad I have you to jog my memory. What fun it is to read your column. Did you get a hard copy this time. I'm actually just getting up and haven't opened the (getting smaller) newspaper yet to see a hard copy. Let me know.
> Lots of Love,
> Claire
>
> P.S. My memories include one of those Annaclair's in the shape of an Easter egg in my Easter basket every Easter along with one big Russell Stover Chocolate bunny and Peeps, of course.
> When I was little, I got to have a grilled cheese sandwich with an orange freeze for lunch with my Mum

at the counter after she finished her hair appointment upstairs EVERY Saturday.

When I was older and paying, I chose their variety of soups that were cheaper...My favorite was their Navy Bean soup with a blob of ketchup in the middle. That was the only place I ever ate bean soup and the ketchup thing was something everyone else did, so I went along with the crowd. The waitress would automatically bring the ketchup bottle after bringing you the soup.

I remember: My mother's hairdresser, Mrs. Ward, who had flaming red hair.

I remember getting off the escalator and seeing my wedding dress in front of me...which I bought for $99.99 without even having anyone to marry in mind. A street length dress (not in the bridal dept.)

I remember Archie Eason's hats...A Cohen Bros. exclusive...Which my mom never bought, but my grandmother tried several on once while visiting us from Pittsburgh. They had a little "signature" sequin things on them. I also saw his hats when he joined the beautiful Virginia Atter and handsome Dick Stratton on their morning show which I watched during summer break. Maybe you could find them for a good story.

I remember the fabric department—which also carried yarn for my needlepoint projects. My mother always bought some fabric before we left.

I remember the pink tile and gritty powdered soap in the "Ladies Lounge" which I always avoided using (unless my Mom caught me) and the very strange concept of squat toilets...Very strange.

I remember the mezzanine where I picked out my dishes and signed up for the bridal registry. My pattern was made by Mikasa and it was called "Margeaux." They were on sale the entire month of my wedding and after hauling about 32 dinner plates back to the lady in the china department, I ended up with 12 five-piece place settings that included all the serving bowls, meat platters, butter dish and salt & pepper shakers. The dishes were discontinued about three months later. But what care I...I had them all. I should have you and Hardy over for dinner. I set a very pretty table.

And lastly, I remember the linen dept and all of the beautiful bedspreads and curtains for my bedroom that my mother would let me pick out through the years (provided they were ON SALE.)

* * *

Another homer, Dottie. Thanks so much for alerting me to your articles. They are so very appreciated.

In this one, I especially liked the way you linked your own father with the city fathers, as if visiting the building today is a reminder of those visits to your dad and a tribute to wise governance by our collective fathers.

I sure have similar memories of Cohens. Wasn't it once called "The Big Store?" That was before my time. I guess it was during the 60s and 70s when downtown declined. Maybe as suburban malls grew? And the highway system?

My father worked in the county courthouse on Bay Street. He and I went to a barber on Bay Street, the old Gem Barber Shop, just a block from the courthouse. When I went to Landon, I would walk from the school to downtown, across the Main Street Bridge, to get my hair cut. That was when boys and men got a haircut every couple of weeks. Our barber was Art Boudreau, and he was a character. My dad even wrote up his memories of Art and called it "Stories of a Clip Joint." It was an old fashioned male space. Interesting to recollect now.

What else do you remember about downtown? Cohens, Furchgotts, Underwood Jewelers, the funky juice shop, the Center, Arcade and Florida Theaters, the Civic Auditorium, Hemming Park, the Universal Marion building with the revolving Embers Restaurant on top. I'm so glad that downtown has revived a bit. Love the new library and city hall spaces and the modern art museum.

Have you read James Weldon Johnson's autobiography, *Along This Way*? His father was head waiter at the old St. James Hotel, I think. The early pages of the book are rich with images of old Jacksonville, before the fire.
Phil

* * *

I enjoyed reading the article in June 27th issue regarding May Cohens Dept Store. I started working for USF&G on Hogan Street in 1956 and would appreciate it if you would advise me of your Dad's name. Your article brought back more memories of places and events in downtown Jacksonville.

H.L. Bryson

* * *

As a young married mother, I worked in the basement of May-Cohen. I sold women's bras, panties, etc.

I was also the Easter bunny one year. A very good one too. My husband was in the Navy at NAS. I moved away but came back and raised my 2 sons here in Jax. A lot of my early memories are tied to the St. James bldg. They are all good memories.

Doris Patterson

CURB SERVICE EATERIES WERE
THE PLACES TO SEE AND BE SEEN

July 25, 2009

When the movie *American Graffiti* came out in the summer of 1973, many of us were amazed at how the film captured the spirit of our adolescence so well—rock and roll, cars and curb service. Maybe in Jacksonville the waitresses at our hangouts didn't arrive on skates as they did at Mel's Drive-in in the George Lucas movie, but we kids in Jacksonville could still sit in the comfort of our cars, be served on trays at our windows and be part of the American teenager scene.

Frisch's Big Boy on Beach Boulevard was one of the biggest of the hamburger hangouts for kids on the Southside. In the yellowish glare of fluorescent lights, kids rolled up in the recently washed family automobiles or their brand-new souped-up cars. Couples or groups of singles came initially to eat burgers, fries and milkshakes, but they were also there to see who was making up, who was breaking up or who was on the prowl.

Jacksonville Beach resident Beckie Saar Leone, sixty and a professional artist, said, "We used to cruise through the parking lot at Frisch's every Sunday night after youth fellowship at church. I can't recall any single event, exactly, but I do remember that there was this wonderful strawberry pie served there."

Another teen magnet in our *American Graffiti* days was the Krystal on Atlantic Boulevard. Its gleaming white tile architecture shone brightly on Atlantic Boulevard across from the Bishop Kenny campus.

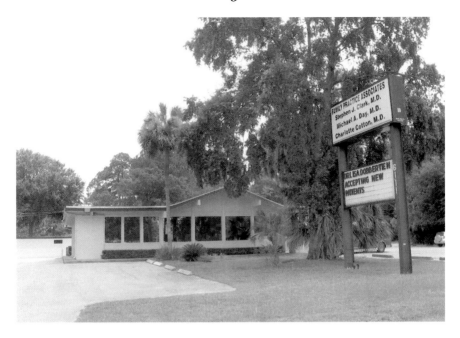

Above: Doctors' office complex where Frisch's Drive-in Restaurant was once located.

Left: The site of the Atlantic Boulevard Krystal Drive-in Restaurant, now Pulido's Automotive.

By the Wayside

Southside resident Shirley Atkins Hartman, fifty-eight and a property manager in Jacksonville, recalls going to the Krystal after Wolfson football games:

> *My friends and I would flock there because you could get ten Krystal burgers for a dollar. Talk about your cheap date; although, I suppose, a dollar was worth a lot more in those days. Still, we had a wonderful time whenever we went.*
>
> *There were lots of kids running around from one car to another...They were mostly re-living the key plays of the game at the Gator Bowl which is where Wolfson home games were then played. But I think there was probably a lot of checking up on everybody else.*

San Marco resident Connie Rutkowski Rennie, sixty-one and a retired English teacher in the Duval County School System, can recall certain hangouts:

> *I know this will be hard for you to believe, but I didn't "hang out" as a teen! My parents would not allow it—besides, I was a bookworm! How do you think I got so smart? I was also a Ramette. I suppose if I hung out anywhere it was mostly at Betty Balformark's Ballet Studio off Atlantic Boulevard. I did go to Frisch's once—after the Prom... but left early as my date was extremely boring and I was tired. Ha! Told you I was weird. I did like the Krystal...but I only visited it when I was skipping mass at Assumption! Ha! I must have been a total nerd!*

Another Southside resident, Lyn White, sixty-five and a retired nurse, remembers when she and her friends "cruised" the Texas Drive-in in the early '60s. "We would cruise from the Texas to the Krystal, then to Bono's on Beach. All had curb service. The Texas specialty was limeade in the tall malt like glasses. If you sucked back too fast, you got a brain freeze. It hurt. We must have cruised all three places all night from one to the other."

Mandarin resident Tom Tankersly, sixty-one and a retired employee of the Duval County School System, remembers three places on the Northside and Westside where he and his friends would "cruise the loop": the Krystal on Main Street, Bailey's across from Jackson High and Pat's Drive Inn. "Cruising these places was the big thing back then. These were places where

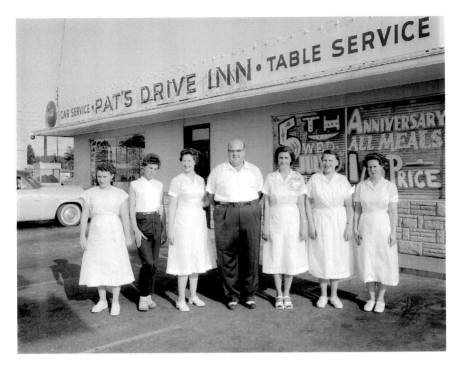

Pat's Drive Inn and staff in 1958. *Courtesy of the Florida State Photographic Archives.*

you could show off your car, and most importantly, they were places where you could be seen. You'd just back your car into a space, turn your lights off and they'd come and take your food order. Sometimes, my buddies and I would hit all three places in one night. Great times!"

Whether we were just "Getting Around," like the Beach Boys, "Cruisin'" with Smokey Robinson or riding along with Wilson Picket and "Mustang Sally," we kids of an earlier age were enjoying a special place in American history that was a celebration of music, cars and dating rituals. Thanks to places like Frisch's, Krystals, the Texas Drive-in, Bailey's and Pat's Drive Inn, teenagers in Jacksonville were right in the middle of the party. And Mel's Drive-in wasn't the only happening place in the country.

E-mail responses to the column:

> Dorothy, loved your column on Curb service. My grandfather and grandmother owned Pat's Drive Inn and were in the picture. I would love to get a copy of

that picture for my mother. My grandparents have both passed away and we don't seem to have any pictures of the restaurant. It would mean a lot to my mother. I also couldn't find it on-line. Is it on-line anywhere?

Thanks a bunch!

Connie Howell

* * *

Another great article, Dottie. Thanks for sharing. So where do you go now for fun like that? Do you have Sonic's in Fla? In Jax I remember, vaguely, an old A&W root beer stand. Was it on Beach Boulevard? Seems like it also had curb service.

As a teen, I was hardly ever at the Krystal or Big Boy. As I read your article I realized why. I didn't have a car. I guess my friends didn't either. Also, I didn't really date, not much. Maybe that was connected to not having access to a car. I went to all the Wolfson football games. I wonder how? Did my parents drop me off? Gee...??? Now I'm puzzled. Every so often they let me use the car for a weekend outing, but it was rare for me to have the car. This brings up the subject of drivers' ed classes. Do they still offer the same course?

Did you already do a feature on drive-in movies?

Phil

* * *

[Submitted by Jaws47 on Tue. 7/28/2009 at 8:27 am] How could anyone write an article on teen nightlife in Jville and not mention the Pennyburger in Avondale where the Loop now resides????

* * *

Hi, loved the article. Certainly brought back old memories of Marion's own loop of carhop eateries—A&W on the east side (also Bowen's home-made ice cream small drive-in), the barbecue place on the north (the name escapes me) and DQ on the west side.

I do enjoy your writing and try to picture Jax back in the day. I just wonder if our kids have anything close to these good memories. Really, in so many ways, it was an innocent fairly safe time for teens.

Linda

THE WONDERS OF PETERSON'S 5 & 10

August 29, 2009

There can be no place more fabulous to a child of the '50s than a dime store, and there was no better dime store in the world than Jacksonville's own Peterson's. The first Peterson's I remember was tucked between the A&P and the Vogue Shoppe of Lakewood Shopping Center. It was a treasure-trove of all the stuff human beings absolutely had to have.

There was a candy counter near the front of the air-conditioned store where a nickel could buy enough to make you sick. Then came aisles of tray-topped counters brimming with merchandise. Everything from cosmetics and sewing notions to school supplies and carpenter nails could be found at Peterson's.

In 1959, when I was in Miss Davis's fourth-grade class at South San Jose, now called Kings Trail Elementary, we had one odious weekly assignment—to write out the entire dictionary definition for thirty vocabulary words. One glorious day I discovered in all the treasures of Peterson's a pocket dictionary in the school supply section. That very day I began saving my allowance so I could soon have the $1.49 for the dictionary with quick and easy one-word definitions. Three weeks later, I held the little dictionary in my hands, and it might as well have been the Gutenberg Bible I was so thrilled.

I can only guess what happened to that dictionary. It didn't turned out to be the panacea I had hoped it to be. Mrs. Davis wasn't fooled by my end run around her assignment. Soon my little dictionary languished on a bookshelf somewhere, but my memories of Peterson's were not so easily lost.

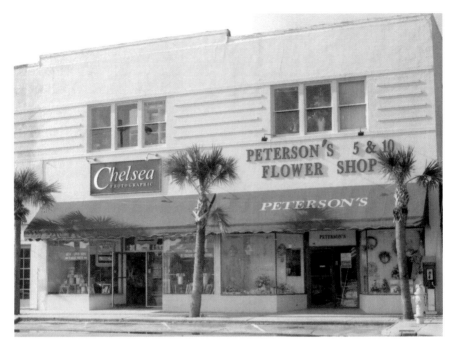

The San Marco Peterson's in 1993. *Courtesy of Chelsea Photographic.*

Neither are they lost to Betty Boyer, a Southside resident and, as she says, "an elderly lady who loves her community." "Peterson's was the very best place in the world. When I was a young mother, I was like all young mothers. I was short of cash. I had to find affordable goods and, at Peterson's, I could. I would get Buster Brown clothes for my children so they could look neat, and it would not cost a lot."

She went on to explain that her own mother had run a dime store during the Depression in Oakland, California, and Peterson's friendly, homey atmosphere reminded her of her mother's store. "It wasn't perfect, but everything you needed was all there."

Ormond Beach resident Mary Jo Pabst Harrington, sixty-eight and a retired paralegal, remembers with great fondness the years her father, Bob Pabst, managed one of two Peterson's stores in the Jacksonville area. "We had moved to Florida from Pittsburgh in the early '50s," Harrington said, "and at that time my father worked a Ben Franklin Dime Store franchise in Lakewood. In 1955 or '56, he and his business partner, Dana Peterson, let the franchise lapse, and the stores then became Peterson's 5 & 10, with Peterson running another store in Timuquana on the Westside."

Harrington, the eldest of six children, worked the cash register for her father almost every Saturday and on Friday nights when she didn't have a date. She said that her father ran the Lakewood store with

> *four women employees who covered the four sections of the store. There were the toy section, the notions section, hardware and cosmetics, the last part filled with Tangee, Cutex and Coty brand products lined up in glass partitioned countertops...Lakewood was a wonderful place to live, to work, and to grow up. The shopping center was a wonderful community of merchants raising families, and it was great to have friends all around—like Gail Grossman Baker who worked at the bakery, and Warren Teal who was my father's stock boy.*

In the early '60s, the Lakewood store moved to San Marco, where Harrington's father went to be manager. There was an addition at this store—an upper floor with rows of artificial flowers and a floral arranger on duty. In the late '60s, Mr. Pabst had a heart attack and left managing the dime store to work at the Walgreen's in Lakewood and for MacKoul Brothers, providers of sundries. In 1972, Bob Pabst died.

As the public's tastes changed and the super stores have attracted away shoppers with more modern sensibilities, dime stores fell out of fashion. But I suspect that even Solomon in all his glory would have marveled at the riches found in stores like Peterson's. I know I certainly did.

E-mail responses to the column:

> Peterson's was not in my neighborhood growing up, but I discovered it when I had children. We lived in Boston and NY, but on trips home to see my parents, my mother took her little grandchildren to Peterson's in San Marco. They absolutely loved it.
>
> In fact, I have a Homeland Security story that involved Peterson's. Well, it happened before we had an official HS gov't agency. In the 1980s, my preschool aged son saw a toy rubber knife in the toy bins at Peterson's. We bought it probably for all of 50 cents. On the way home, we packed the rubber knife in his little luggage pack. Airport security spotted it on their X-ray machine and opened his pack and insisted that he could not take it on the airplane. We had to leave it behind at the Jax airport.

The memory of the rubber knife came back to me almost immediately after 9/11. I thought, "How could airport security allow real box cutters on airplanes in 2001 when they wouldn't allow a harmless rubber knife in 1986?"

Phil

* * *

I had forgotten all about Peterson's until you mentioned the flowers!

Susan

* * *

Weren't they wonderful stores? I remember Tangee products or at least the lip stick ads—didn't know they made anything else. Do you know about the Harriet Hubbard Ayers beauty products? My grandmother Woodall was addicted to them. Also whatever happened to soaps—not only the lowly Octogon bar but Cashmere Bouquet and Lux? Did they make a last appearance in the five and dime?

Byron

* * *

Hi:

I loved it. Brought back memories of the old Woolworth's on the square in Marion two doors away from the movie theater. We also had an "Economy Store" on another side of the square—smaller than Woolworth's. I don't remember when they closed, but what a loss they were.

L.

* * *

I used to go in the store in Lakewood a lot and remember Mr. Pabst. Very nice man. Years later, one of my best friends, Al Cooke, married his other daughter, Kathy. Kathy and Al introduced me to my wife. Small world.

William Spiers

WHEN TELEVISION PLAYED A HISTORIC ROLE IN THE CLASSROOM

September 26, 2009

Maybe it was because of recent news coverage on the anniversary of the lunar landing or the death of Walter Cronkite, the calm CBS anchor of our tumultuous youth, but these recent stories carried me back to elementary school when television was new and American children were far less worldly-wise.

The television set was rarely brought into the classroom during those days. Even so, on May 5, 1961, Miss Thomas rolled the library's TV set into our fifth-grade class at South San Jose Elementary. Then we counted down to the liftoff of Alan Shepard, the first American to travel into space. "10...9...8..."

Finally, the little rocket rose on the tiny black-and-white screen, and we let out a patriotic cheer.

Alan Oakun was in Miss Rooks's fourth-grade class just down the hall from me. For him the launch was "like we were watching something we'd never seen before, and I kept wondering if this was really outer space or science fiction. And I kept asking myself, 'Is this actually happening?' We all had our mouths opened in awe as we watched the spaceship go up."

Southside resident Ivy Ludwig Eyrick, fifty-eight and retired production manager for Theatreworks, was a student just up the road at San Jose Elementary. She remembers her class being taken into the cafeteria to watch the liftoff. "As I recall, we somehow watched it on a big screen. I

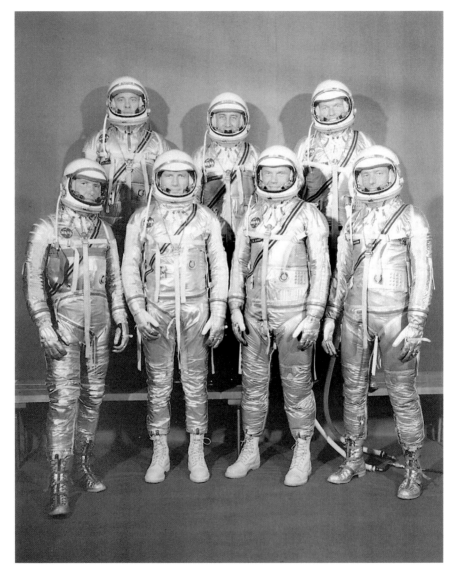

Alan Shepard and the other *Mercury 7* astronauts in 1959. *Courtesy of NASA.*

also remember that we were all into making space projects then. We had spaceship models and posters everywhere."

The day after the liftoff, the *Times-Union*'s front-page headline read, "Perfect Flight Gives U.S. Big Boost in Space Race." The thirty-seven-year-old astronaut Alan Shepard was quoted as saying, "What a beautiful sight!"

Alan Shepard preparing for a space flight. *Courtesy of NASA.*

at the top of his fifteen-minute "hop into space." So began America's reach toward the moon, and television let us go along for the ride.

Another quaint memory I have of televisions in the classroom was the annual viewing of World Series games during school hours. Southside resident Edward J. White, fifty-eight and senior vice-president at Bank of America, and his classmates in Miss Rooks's class were allowed to watch the games. One particular contest held special meaning for him—the one between the Pittsburgh Pirates and the New York Yankees in 1960. "This was the World Series in which I took a keen interest since my favorite player was Roberto Clemente, and he played for the Pittsburgh Pirates. I also recall that Bill Mazeroski won the championship for the Pirates with a homerun in the bottom of the ninth!"

Even the girls were interested in baseball and the race to beat Babe Ruth's home run record. I was a Roger Maris fan in 1961. Maris eventually broke the Babe's record during the last game of the season, but my father remained loyal to his favorite, Mickey Mantle.

Unfortunately, it wasn't too many years later that televisions were used to bring our country's tragedies to our classrooms. When President Kennedy was shot, lessons were suspended for the day, and several classes at DuPont Senior High gathered in one room to witness chaotic events in Dallas. For once, we were absolutely silent.

Eventually, television became a fixture in education. By the time I became a teacher, we had videotaped lessons, movies and documentaries as prevalent as sets of books, and the students in this generation were not often impressed by whatever came on TV. How nice it would be for our children to be filled with a sense of wonder at the prospect of watching great games contested or witnessing tentative steps toward the future.

TRAINS HAVE INTRIGUED IMAGINATIONS
FOR GENERATIONS

October 31, 2009

In elementary school, we sang many songs that had to do with trains. We sang about "working on the railroad" or listening to that "lonesome whistle blow" or about Casey Jones, the brave engineer.

We also listened to a world-famous train song associated with Jacksonville, "The Orange Blossom Special." Supposedly, Robert Russell and Ervin Rouse wrote the song in the late '30s in their hotel room after they toured a luxurious train in the Jacksonville Train Terminal, now the Prime F. Osborne III Convention Center.

Trains seemed to have captured the imagination of earlier generations, and America's love of the rails was transferred to us Jacksonville kids early on. At least here, we children had two ways to satisfy our desire to "ride the rails."

Mandarin had a scale model, steam locomotive that pulled a little train, just big enough for children to sit in. Every weekend one could find many children and their families riding around the half-mile "Mandarin Loop" for the price of a dime (eventually twenty-five cents when the little train took its last turn in the late 1960s).

I vaguely remember taking a Sunday drive into the lush greenery of the Mandarin area not long after we moved to the Southside of Jacksonville. We happened on the Little Train there almost by accident, and my little brother, who was certain that he would be an engineer when he grew up, almost lost consciousness at the thought of riding a real train. Quickly, we found

Left: Engineer Ward taking the little train of Mandarin through the lush undergrowth of the Mandarin woods. *Courtesy of photographer Tom Markham and Bob Leynes of the Florida Railroad Company.*

Below: The little train at the Jacksonville Zoo.

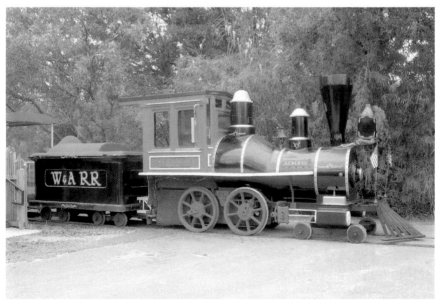

ourselves chugging around the circuit, and all the while my little brother was beaming with joy.

Mandarin resident Bill Marrow, sixty-six and a retired physician, actually grew up in Mandarin and still lives in the house of his youth. "The little train there is one of my earliest memories. I even have a picture of me and my twin brother when we were about two or three, and our aunt had taken us there. It was great to get to ride."

Morrow said that there wasn't too much to do out in Mandarin when he was little except make his own fun, so riding the little train was a special outing. The little train ran on Sundays, sometimes on Saturdays and on most holidays. Morrow lived so close that he and his family could often hear the little train whistle whenever the train was running.

That same train whistle had a special meaning for Dr. Paige French, fifty-nine and assistant principal of curriculum and instruction at Providence School:

> *My great uncle had an orange grove in Mandarin, and every other Sunday we would go out there. My parents would try to distract me before we got to Uncle Jack's house, but at the sound of the whistle I would get excited and want to ride!*
>
> *My grandfather would usually take me back to ride the little train, and it became "our little thing" to do. It made me feel so important.*

On the other side of town another little train took children on rides and still does today—the one at the Jacksonville Zoo. According to Allen Ross, the unofficial historian of the Jacksonville Zoological Gardens, the little train made its first journey around the track on April 29, 1956. This train attraction was and is very well attended. It was simply a given that after a full day of looking at lions and tigers and bears, kids just had to get "All Aboard" the little zoo train and travel the perimeter of the grounds.

When my daughter was about eighteen months old (sometime in the mid-'70s), we took her to the zoo. We realized right away that she was probably too young to appreciate what a zoo is all about. Weeds and bugs on the sidewalk held her attention more than the elephants and gorillas. Even so, when she spotted the little train she perked up. As a matter of fact, we had to ride it twice to make her day complete.

Why riding the rails has such a magnetic hold on humans, young or old, is something only psychologists and philosophers can explain. More than likely, trains represent freedom from the mundane and travel to exciting

places, even if it is just in a circle. The little trains of our childhood, the one in Mandarin and at the zoo, certainly have added to the train mystique for those of us lucky enough to have ridden them.

E-mail responses to the column:

> Hi Dottie, thanks for the new feature about railroads. I never knew about the one in Mandarin, but I sure did ride the little train at the zoo. Do you suppose school field trips still go out there?
> Phillip Smith

* * *

> Dear Dottie: Thanks for the article on little trains. One of the enjoyments in otherwise deadly dull diaries of old man Munger, my uncle, was his recollections of being awakened in the night by train whistles and being able to identify which train it was by the sound of the whistle.
> B. Riggan

* * *

> Loved the article on trains. Between Marion and Carbondale a train hobbyist built his little rail line that ran through a small wooded area. I can't remember how many years he operated, but I took my own daughter(s) (can't remember if both girls rode or not) to the train as something to do on a Sunday afternoon. Of course, it went by the by also.
> About the zoo train—it got me wondering—have you done anything on the growth of the zoo? I think our Jacksonville Zoological Gardens are really something. I'd love to know more about how it turned from a simple concrete/bar cage zoo into the beautiful park it is now.
> Linda Allen

* * *

Did you know about the "Great Mandarin Train Robbery"? Seems that one Sun. afternoon the train was about 1/2 way thru its run when, all of a sudden, here comes about 1/2 dz. good ole boys on horses, wearing bandanas over their faces, firing pistols in the air (of course real!). They stopped on the tracks and made the train stop. The engineer was mad as an old hornet. We teens thought it was cool (not much happening out there then, you know). Little kids were crying, the bandits came down the tracks collecting our charm bracelets, etc. in brown bags. Then, they took off hooting and hollering and firing their pistols. Wow!! Great fun!! Of course, the bags with our stuff was at the station when we pulled in, but the engineer wouldn't give any more rides that Sunday. It was worth it, though. Took me years to find out who did it, but I promised not to tell.

The first story I wrote for the old *Mandarin News* years ago was "The Great Mandarin Train Robbery"! I still have copies of the original *Mandarin News* with the stories. I did features like the robbery and so on, a column called "Ramblin'" about the good old days out there and 2 editorials a week. One guy told my boss he wanted to meet the little old lady that worked for him. John told him he didn't have any little old ladies. The guy told him sure he did, the little ole lady that wrote "Ramblin'"—gotta be older than dirt 'cause she'd never forgotten anything that'd ever happened out there (I was in my 30's!).

Cheryl Taylor

* * *

I love the picture of the train. Is this the train that was in Mandarin? I remember our parents taking us there. I loved that train...of course I love trains anyway.

Marty Martin

RACIAL UNREST DISTURBED
THE JACKSONVILLE SUMMER OF 1960

December 5, 2009

In 1960, Jacksonville was not only about bobby socks, milkshakes and joy riding to dances. It also had a shameful side—racially segregated restrooms, water fountains, restaurants and schools. Most white kids were oblivious to the meaning of all this, but black children were painfully aware of these indignities.

On Sunday, August 28, 1960, the *Florida Times-Union* ran a news brief on the front page. It noted, "Police clamped a tight security lid on Jacksonville last night following a day of racial unrest." In the second section, an article noted that thirty-three blacks and nine whites had been arrested on charges "ranging from inciting to riot to fighting." We who lived outside the city limits didn't have a clue.

There is a story told in my family that my uncle who lived in Chicago called us in a panic. He wanted to know if we were all right. Were we safe and secure, and did we need to come and stay with him in Chicago for a while? Naturally, we were confused by his questions. There were no hurricanes threatening our coast, and the Naval Air Station directly across the St. Johns River from us was not under attack. Of course, we were just fine. Why was he asking such strange questions?

It seems that the television and newspaper coverage in Chicago told of wild riots in Jacksonville streets. My uncle had seen that looting was widespread, buildings were being set ablaze and the National Guard was on standby for mobilization if order was not restored soon.

The historical marker in Hemming Park of Jacksonville.

My family was shocked that such news was making the circuits in northern cities since nothing out of the ordinary seemed to be going on in our fair city. My father, who worked downtown, had not seen anything violent during the week. That was because the unrest in the downtown area occurred during the weekend.

Author Rodney Hurst, sixty-seven and a retired Jacksonville city councilman who served two terms, recounts his view of that "unrest" in his award-winning book *It Was Never About a Hot Dog and a Coke*. Hurst said that the riots stemmed from attempts of young blacks to integrate the segregated lunch counters of stores in downtown Jacksonville—Woolworths, W.T. Grant and Kress's. These sit-ins led to what later became known as "Ax Handle Saturday" when whites attacked black demonstrators with baseball bats and ax handles.

Hurst was just sixteen when he was president of the Jacksonville Youth Council of the NAACP. He led some of the sit-in demonstrations during the summer of 1960. He said, "We were always to purchase something in

the store first before moving to the segregated counters. We were to protect ourselves, of course, but we were not to respond to taunts and disrespectful comments. Only the 'sit-in captains' were to do the talking; but soon after the first day, the trouble started."

Arlington resident Ken Manuel, sixty-five and a retired Duval County Public School administrator and now associate state director of the Southern Association of Colleges and Schools, also witnessed some of this violence. He was in his father's restaurant, Ivory's Chili Parlor, right across from the Strand Theatre. "Many individuals retreated toward Ashley Street which was a Mecca for black folks, and I saw them running past through my father's storefront window. The riots also occurred on Florida Avenue which was heavily looted and burned."

Manuel was childhood friends with Tommy Hazouri, sixty-five and Jacksonville's future mayor and presently outgoing Duval County School Board chairman. Together they played in the grocery that the Hazouri family owned, operated and lived over. The Manuel family even rented a house behind the store from Hazouri's father, but the boys could not attend the same school.

According to Tommy Hazouri, "The neighborhood was one big happy family, though. All the kids, black and white, skated and played ball together and didn't think anything of it."

And Manuel can still reflect on his youth here with fondness. He played baseball, and he and his friends often went to American Beach, the only beach open to blacks back then. In 1962, he was elected senior class president at Matthew W. Gilbert. He went on to Florida A&M, where he majored in elementary education and where he met Roberta, his future wife.

It is never easy to look back at segregation, but it is only by recalling such times that we can ensure that such injustice against any of our citizens is never repeated, and then racial harmony can be more of a reality than a promise.

E-mail responses to the column:

> About the riots in 1960...My father, Haydon Burns, was Mayor of Jacksonville at that time. He went to Ashley St. in the middle of the riots, and helped to calm them. It was an unpleasant, scary time for all in Jacksonville. Many of us became aware of the evils of segregation during this time. Eleanor Burns Watkins

* * *

Memories do exist, however slightly from this dark history in Jacksonville. Certainly of the segregation which was so obvious and prevalent. Not flaunted or seen much as indicated outside the city limits. My father's business was in the retreat area however and that period in the last weeks of August 1960 those memories do exist. Memories with fear and comfort of seeing the tension on Ashley St. both adjacent to Herbert the Taylor and immediately across the street from El Chico Bar. I don't remember the name of the multi-lease shopping department store on the opposite corner, but during the rush of some back to this area or protected territory, both racially mixed businessmen and friends shielded each other from any possibility. It was from this group that Herbert the Taylor's son became a Rhodes Scholar and the Hazouri family became so successful in the food business. I didn't know Tommy Hazouri but a family friend was Rufus Hazouri, perhaps his father or another family member. That and so long ago memories is what keep Jacksonville so warm in my heart.

Ian Jay Germaine

* * *

I remember those days and had a maid that wouldn't let us cross the Main Street Bridge to take her home if she had to work later than usual and missed her bus. They were fearful times for both blacks and white.

Take care and keep writing about Jacksonville's past.

Happy Holidays!
Nelle Walker

* * *

Good one, Dottie. Two images come to mind for me in southern Illinois. I was a teen in the mid-1950s working

behind the lunch counter at West Side Drug Store. There was never anything posted anywhere in Marion that said "for whites" or "for coloreds." But the lines were there— only unwritten. A young black girl came to my counter and asked for a Coke. If people drank it there, we put it in a glass, but if it was "to go" we put it in a paper cup with a straw and lid. I automatically said, "Here? or to go?" She just stood there looking at me with an expression that said, "Are you stupid?" Out loud she said, "I can't drink it here." I was embarrassed and mumbled an "oh" and gave her the paper cup of Coke.

I became friends with a black boy named Kenny from one of my classes. We spent many lunch times at school together. Kenny described racial prejudice to me, the injustice, and so on. It was a real eye-opener for a sheltered white girl. One Saturday as I rode with my parents across town, I saw Kenny mowing a yard. I waved and yelled out the window, "Hey, Kenny!" My dad said, "Put your hand down." And I said, "But, Daddy, that's my friend Kenny." And he said, "Put your hand down. White girls don't wave at colored boys." It was the first time I had heard anything like that from my father. I was furious. I remember saying, "At church (we went to the Baptist one at that time) we sing 'Jesus Loves the little children of the world, red, and yellow, black and white, they are precious in his sight. Jesus loves the little children of the world.' Are we singing a lie, Daddy? Are we singing a lie?" My dad and I could never talk about the subject again (without arguing).

Years later as I worked on my masters in history, I researched black history—especially in southern Illinois. I learned a lot—enough to be amazed, ashamed, and, believe it or not, one of my research papers was requested by a black woman who heard about it and asked for a copy. I told her it wasn't much because there was so little written (I had used census records to plot where they lived as they moved into Williamson County, oral reports from interviews with older black folks, some written things). She said, "You don't understand. Your paper is all we've got." Really sad.

And finally, my first published play deals with racism (the teens at FPC Marion requested that as the subject for the script). We performed "His Colors" all over southern IL and finally before the big Martin Luther King, Jr. birthday gathering in nearby Carbondale (university town). Linda

* * *

Aahhhhh, you have opened the floodgates of my youthful memories and I am waxing nostalgic. I remember the John F. Kennedy visit as he was running for President. He landed at the old Imeson Airport and motorcaded down Main Street in an open convertible, past my house at 10th and Main Street. People lined the street and my family was among them. We waved at him and he waved back, not just at us, of course, but it almost seemed that way. I remember when Captain Kangaroo (Bob Keeshan) also came to Jax, as did Elvis, and later (1970s) the Rolling Stones. Of the movie theaters that were once downtown, only the Florida Theater remains. But I remember the Center and the Empress, the Imperial, the Capitol and the old Ritz. Jacksonville was segregated then, and the Ritz was a "colored" theater. I can remember Setzer's Grocery on 8th when it had water fountains marked "White" and "Colored Only." Gosh, how times change. You really got me going, but I will stop, now. Thanks again for the trip down Memory Lane.

Bill Chappell

DRIVE-THRUS MADE LIFE EASY
FOR ON-THE-GO CITIZENS

Today in Jacksonville, there are many drive-thru establishments—dry cleaners, banks and hamburger joints. However, in the not-so-distant-past, drive-thrus often provided a wider variety of services than are offered now.

One of those interesting drive-thrus my family often frequented was a Skinner's Dairy Store, located on Bowden Road right across from the Skinner Homestead. Of course, there was an earlier time when a person called a milkman came to our home and left Skinner's milk products in a small metal box by our side door. My mother would leave him messages about what we needed, and the next day it magically appeared in the little box.

But the days of the milkman came to a close, because it was so easy to buy milk products at the grocery store. So, Skinner's Dairy came up with a brilliant plan—a series of drive-thru dairy stores sprouted all over the city, twenty-five of them in fact between the years of 1958 and 1983.

At our store, we would get homogenized milk, skimmed milk, buttermilk and chocolate milk. We could get butter, cream and sour cream, and as I recall we could also get eggs and loaves of bread. At Christmastime there was eggnog, I think.

A very different kind of drive-thru once existed at the corner of St. Augustine Road and University Boulevard. Today, there is only a vacant lot with shrimp vendors or people selling rugs with Elvis's face on it. But once upon a time, a garish, orange, two-story building stood at that corner. It

The Skinner Store on Parental Home Road was most recently a coffee drive-thru and is now vacant.

was called the Southside Package Store, and here adults could purchase all manner of alcoholic beverages—to go. They could drive right up, order a miniature and a cup of ice and be back on the road in no time.

The store had an interior room filled with vodka, gin and whiskey. Upstairs, I am told there was a bar, but what I knew best was the drive-thru window with sliding glass doors. My parents made more than a few stops here during my childhood. My siblings and I loved to drive there since the salesperson always gave us each a lollipop as they handed the adult purchases to our parents.

Of course, these were the days before anyone realized how impaired one could become after a few drinks, and it certainly was before the open container laws had gone into effect. It was also before there were seatbelts or child safety seats. How did we ever make it to maturity, I wonder.

Probably, the most interesting, but unsettling, of the drive-thrus was at Dorman's Funeral Home, which was located farther down on St. Augustine Road. Walter L. Dorman was the licensed funeral director who was forward-thinking enough to provide a large picture window on the building's road side by which one could drive or walk to pay respects to the dear departed.

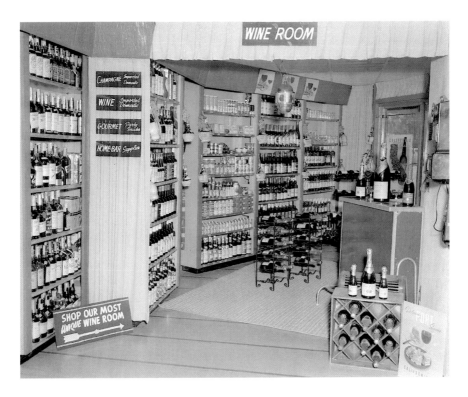

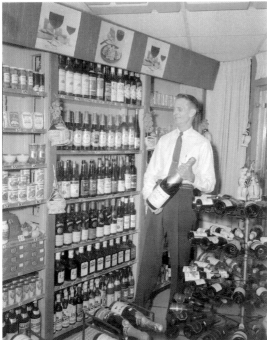

Above: Southside Package Store's interior, 1957. *Courtesy of the Florida State Photographic Archives.*

Left: Another picture of the interior of the Southside Package Store, with unidentified employee. *Courtesy of the Florida State Photographic Archives.*

Above: Dorman's Funeral Parlor, now North Florida Construction.

Left: Dorman's Funeral Parlor's viewing window and steps.

Small steps are still under the window that is now part of the main office of North Florida Building and Construction.

When I went to look at the site, April Bradley, the twenty-four-year-old office manager, first showed me the present kitchen where once an embalming room was located. The large lobby was obviously the main viewing room since it still has the picture window on the left as you enter the building. On the right, three little rooms with large doorways now serve as smaller offices.

I was unable to verify in print that the viewing drive-thru was part of the establishment. I am simply going on hazy stories told by friends at school, but places as far-flung as Chicago and Pensacola boasted of drive-thru funeral amenities, so why not Jacksonville? Even *Life* magazine had an editorial in its May 10, 1968 issue bemoaning the fact that Americans were a people too much "on the go" with such crass drive-thru venues for saying goodbye.

Still, I don't think that Dorman's Funeral Home on St. Augustine Road was trying to be trendy. It was a very small building, and a viewing window would have been a practical means to manage large crowds, especially on sunny days.

Drive-thrus have been very much a part of the American landscape ever since the advent of the car. From the most wholesome of products to the adult beverages to the sad and almost macabre—Jacksonville's on-the-go citizens have patronized such drive-thrus as they do today. Do you want fries with that?

THE BIG STINK

An Age-old Problem Finally Conquered

January 29, 2010

It is actually hard to remember this, especially when I sit outside on my deck and take in a deep breath, but there was a time in Jacksonville when such an activity might have caused a fit of coughing. Jacksonville had a nasty little problem for too many years. When the wind was coming from the wrong direction, the acrid smell of paper mills and chemical plants might drive a person indoors on the prettiest of days.

According to the website of Jacksonville's city government, "The primary contributors to the odor problem were two paper companies, two chemical producers and the city's own Buckman sewage treatment plant." It really didn't matter who was to blame. Citizens of Jacksonville simply had to endure the smell.

In high school my friends and I jokingly called Jacksonville "the armpit of the universe," and sadly our opinion wasn't far from the truth. Jacksonville's odor was tainting our reputation.

Whenever my college roommate, Trisha Richards, would come from Clearwater, Florida, in the early '70s, she would remind me how "fragrant" the Jacksonville area was. She would frequently gasp and ask how people could live here with such bad smells in the air. Me? I could no longer tell how bad it really was.

Southside resident Claire Fleming King, sixty-one, had this to say. "My relatives, all being from Pennsylvania, dealt easily with Pittsburgh's sooty,

Tommy Hazouri taking the oath of office in July 1, 1987, as mayor of the city of Jacksonville. *Courtesy of the* Florida Times-Union.

smoky haze that hung over their city like an umbrella. Jacksonville's ever-present stench from the chemical factories and paper mills wasn't as visible to the eye, but the first words out of the mouths of anyone visiting from out of town went like this, 'WHAT ON *EARTH* IS THAT SMELL?'"

When I asked David Owen, fifty-six and purchasing manager for Custom Wholesale Floors, if he remembered "the smell," he said, "Oh, yeah! I was in the first grade at Norwood Elementary where my mother was a teacher. When we hit the expressway, talk about a stink! And our classes were not air conditioned either."

Connie Rutkowski Rennie also remembers what the smell was like. "We didn't actually dwell on it too much—we just accepted it. The paper mill smell was noxious. It was a sweet, rancid aroma, I remember well, and I remember the elation of my parents when someone finally came along (Hazouri, I believe) to rid our city of it forever."

It was indeed Tommy Hazouri, the third mayor of Jacksonville after consolidation, who eventually made things change, and he considered it one of his crowning accomplishments as mayor:

> *We were ahead of our time in this area. The offending companies kept saying for us to accept "the smell of money," but we knew they were simply*

trying to get that last full measure of money out of their enterprise. I am very proud of what we were able to do. If we hadn't, we'd never been able to get new companies or industries to come here. They would get off the plane and, almost before they hit the pavement, they were turning around to go home.

According to the city's website, it was not long after Hazouri was sworn into office that he "asked City Council for an anti-odor ordinance with teeth, and in March 1988 the Council increased fines from $500 to $10,000 per offense. Noticeable improvement to the city's noxious air began soon thereafter."

Those of us who have lived and worked here any length of time are extremely grateful to Hazouri's administration. Now the most recognizable scent in our city's air is the roasting coffee at the Maxwell House Coffee plant. And the occasional smoky smell from springtime wildfires in the Okefenokee. Such a monumental difference.

OLD-SCHOOL TOYS

Popular Crazes Were So Much Fun

December 26, 2009

As I have said earlier, I inherited a large box of knickknacks when my father died in 2006. Included with military medals and ribbons, pipe stems, watch fobs and loose poker chips, I found about thirty miscellaneous family photos. One of the most remarkable was taken in the year 1959, if you can believe the pencil notation on the back.

The photo is of my twenty-nine-year-old mother and my six-year-old brother, and he sat at her feet as she skillfully maneuvered about her waist a new and popular toy called a Hula-Hoop.

Hoops were not new to the American culture. My paternal grandfather said he used to roll one with a stick down the street in his youth, which was sometime at the turn of the twentieth century. In the late '50s and early '60s, however, the hoop hit the popular culture again, only this time the hoop was plastic and its function was different. It was meant to encircle the torso as the person "danced the hula" to keep it from falling down around the ankles.

Who could have foreseen the mass acceptance of such a simple toy idea? As if hit by a tidal wave, and as the picture testifies, my family was swept up in the craze just as everyone else in the neighborhood was. Everywhere you looked, kids were showing off how they could for hours on end make these things swirl around the neck, the knees and the waist.

This interesting photo accompanied a news article that ran in the women's section of the *Times-Union* in 1959. How my father came to own the actual

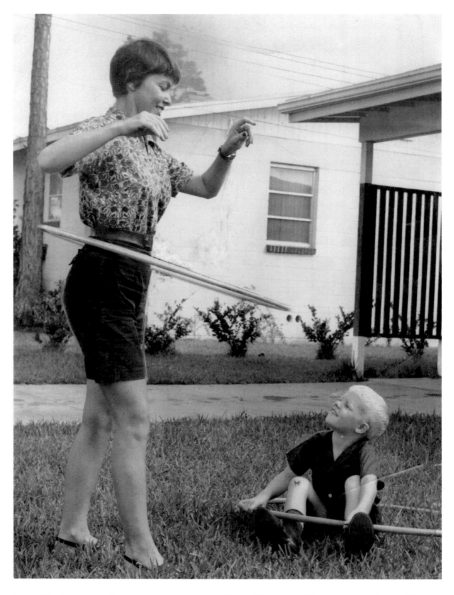

Betty Ketchum showing her son how to use a Hula-Hoop in 1961. *Courtesy of the* Florida Times-Union.

photo, I will never know since my father is no longer here to tell, but it does preserve for all to see that my family was all about the fads.

When go-go boots appeared on the dancers of the TV variety show *Hullaballoo,* which aired from 1965 to 1966, I was one of the first in line

the next weekend at Ivey's Department Store to buy a pair. They cost me one month's babysitting money, but these beautiful white shoes weren't all I had dreamed they would be since they disintegrated after only one day at school.

My family and I were not the only ones to succumb to the lure of the latest "thing," though. San Jose resident David Owen, fifty-six and purchasing manager for Custom Wholesale Floors, remembers that he, too, had many fad toys: the Slinky, the Frisbee and his absolute favorite, the Jimmy Jet.

"It was back in the late '50s, and one of my favorite toys was a console-like thing called a Jimmy Jet. It was about the size of a large shoe box. It had a window screen that had scenery changing before you as if you were flying a jet. I loved it!"

Southside resident Lenora Wilson, forty-seven and a team leader in the Early Learning Department of Jacksonville Children's Commission, remembers begging her parents for a set of Clackers. These consisted of two hard plastic balls connected by strings to a handle. The object was to get the balls to hit over and then below the hand, making a loud, often annoying *clack*! "I hit myself in the face more than once trying to learn how to make these things work properly; and eventually so many of us had them that they were soon banned at school."

Of course, talking about this reminded us both of a thing called a Bo-Lo or Fli-Back. It was a hand paddle that had a rubber ball connected to it with a long rubber band. The player was to keep hitting the ball for as many returns as possible. The only drawback to this toy was that once the rubber band broke, the paddle could be used for spankings.

My friend T.J., who is fifty-four and a teacher in the Duval County Public School System, told a rather poignant story about toys. "I lived in an orphanage for the first five years of my life, so I didn't have any toys to speak of; but one year, my grandmother's sister gave me a pair of Raggedy Ann and Andy dolls with the little hearts that said 'I love you!' on them. They became my best friends, and I couldn't be parted from them. I have even passed them on to my daughter because they are that precious to me."

There eventually comes a time when, like Puff the Magic Dragon, our lives "make way for other toys" and grown-up things. But it is hard not to remember with great affection the many gizmos and fads that filled out leisure hours with such fun.

E-mail responses to the column:

Looking at your mom's picture—and remembering her face as I knew her so many years later—I am reminded that all of us old folks were once young and beautiful and able to hula-hoop (well, some were.)

I guess all of us have memories of our favorite Christmas presents. When I was twelve (TWELVE!) I got a doll dressed in a beautiful aqua taffeta party dress and wearing a little straw hat. Her disjointed body still exists, and whenever I see Sally I wonder how many twelve-year-old girls still receive a doll for Christmas (not too many, I'll bet.)

Hope we all have a good year in 2010.

Pat B.

* * *

What a great photo of your mom! Everything about that picture says "1959." The neighborhood, the house, the new shrubbery, the carport, the driveway, her shorts. But not her haircut, which I love. My mom had perms. Love your mom's look.

Just yesterday, on Christmas morning, I was telling Harriet how I remember Christmas mornings with lots of children out on the neighborhood street riding new bikes, with roller skates, pogo sticks. Now, it's much quieter on Christmas morning streets in America. More indoor toys. Just then two pre-teens came flying by our window on new skateboards. I felt better.

Phil

* * *

Happy Hanukkah belatedly and have a wonderful New Year. Your article on fad toys of the past and the recalling of your friend T.J. as an orphan during his early years reminded me of part of a Confirmation Class project around 1958 or '59 to the "orphanage" off

Parental Home Rd. Sort of an early "Toys for Tots" near Skinner's Dairy to deliver some of the same toys you refer to in your piece. We weren't as clever as "Toys for Tots" though, we just called it a "Mitzvah."

Jay

* * *

I couldn't miss reading the "hula hoop" story in the TU this morning. Your mother looked like my wife did back in the late 50's...slim and trim!

The article brought back the "clackers" that rattled in the gym when our boys were in junior high. And the "slinkies" were always tumbling off stacks of books and stairways in our house.

Those were really Good Ole Days.

George Winterling

* * *

Enjoyed your memories of the "good ole days"...I was a hula hoop addict...tried it again recently with the inner city girls I work with and confirmed that fifty-year-old knees aren't like 12 year-olds—couldn't walk for a couple of days—Your mom was quite the looker...thank you for sharing. Looking forward to more of your fun articles.

Claudia Scott (former Ho Jo girl)

THE GOOD OLD COLISEUM,
GONE IN A CLOUD OF DUST

Perhaps the most important of all events I ever attended at the old Jacksonville Veteran's Memorial Coliseum was my own graduation. Most other Jacksonville public high school students have had their graduation ceremonies there as well. Of my special event on June 6, 1968, I remember cheering and crying as we graduates of Wolfson Senior High School enjoyed the culmination of long years in the classroom signified by our march across the stage to receive diplomas.

The Coliseum had already been the scene of many other wonderful times for me. There was the wonderful night my first boyfriend and I went to see Bob Dylan in concert. It was more than magical as Dylan rasped out about how "The times they are a changin'" and my boyfriend and I held hands in the dark. Dylan's words proved most prophetic. My boyfriend's family very soon thereafter moved far, far away and out of my life. So it goes.

And there were other fun times in the very spot where many of us have listened to "Pomp and Circumstance" being played by the high school band. Ice skating afternoons, wrestling matches and the circus.

I suppose when my own daughter graduated in the very same venue some twenty-six years after me, I felt a wonderful sensation convincing me that permanence and tradition are good things indeed. It wasn't long, however, before the need for a new arena became evident, and the old Coliseum went the way of the dodo. It was demolished in 2003. So it goes.

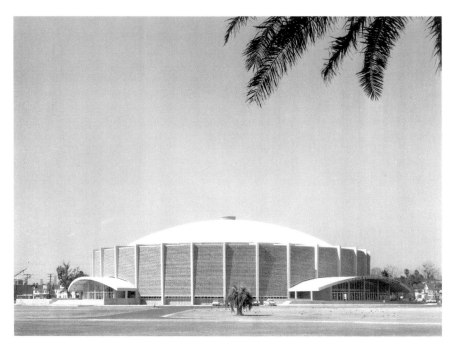

The Jacksonville Veteran's Memorial Coliseum in 1960. *Courtesy of the Florida State Photographic Archives.*

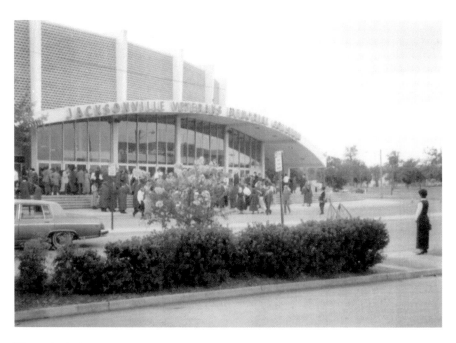

The author's daughter's graduation in 1994 at the Coliseum.

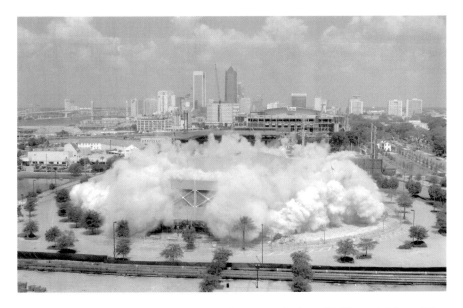

The implosion of the Coliseum to make way for the new Jacksonville Veteran's Memorial Arena, June 26, 2003. *Courtesy of SMG.*

According to my husband, his own father was part of a construction crew that worked on the building of the Coliseum back in 1959. Bill Fletcher had just been laid off at the A&P and needed to provide for his family. He went down soon after and got a job as a laborer.

My husband Hardy said, "My dad worked there until the Coliseum was finished, and he always mentioned his role in its creation every time the two of us passed the building in the car."

So many wonderful performers have put on shows at the Coliseum— the Beach Boys, the Zombies, Wilson Pickett, James Brown and the Association—but perhaps the most famous was Elvis. South Carolina resident Barron Pilgrim, who is sixty-five and a manager at Kmart, has an actual connection to Elvis and the old Jacksonville Veteran's Memorial Coliseum. Pilgrim was at an antique store in Lexington, Georgia, when he came upon a microphone that had been used by Elvis in his 1972 Jacksonville performance. Pilgrim missed the 1977 Columbia, South Carolina Elvis performance because the King died the summer immediately following the concert Pilgrim was unable to attend. "It was almost like finding the Holy Grail. So I bought the microphone and, in doing my research about it, I found out that it had been stolen from the stage of the Jacksonville Coliseum by a guy named Mike. He apparently rushed the stage of the

The Arena as it is today. *Courtesy of SMG.*

Coliseum after Elvis had finished and just lifted the mike, stand and all. It was amazing that he wasn't caught," Pilgrim said.

"I contacted Graceland to see if they wanted the microphone back, and they said for me to keep it. So I had it gold-plated, and I keep it with all my other Elvis memorabilia."

The new Jacksonville Veteran's Memorial Arena is a beautiful place to see, and when I recently saw the Eagles perform there, I knew the acoustics were infinitely better than those of the old Coliseum. Still, there is a part of me that misses the old building with its circular design and bright, airy, "modern" exterior. Too bad we can't gold-plate our memories of the good times we have had at the Coliseum. Oh, well. So it goes.

POSTSCRIPT

There were many childhood summer nights when I lay awake in my bed because of the heat. Our nice house, with its furnace to keep us toasty in the winter, was not so wonderful when the summer sun and humidity made it into a little oven. It wasn't until I was in college that my family finally put in a window unit air conditioner, and of course, I was gone by then.

As I would toss and turn in my damp sheets on those hot, hot nights, I literally worshipped the rhythmic sweeps of the oscillating fan that blew across my room. In between the breaths of moving air, I would try to concentrate on the sounds just beyond my window screen, sounds that along with the heat were part of a Florida night. Frogs, crickets and cicadas called to one another and to me until I finally drifted off to fitful sleep.

Years later, when I was an English major at FSU and also spending many hot evenings in my un-air-conditioned dorm room, I discovered one special writer—Marjorie Kinnan Rawlings. How I had gotten so far in my life without having read her Pulitzer Prize–winning book *The Yearling* I'll never know, but I was immediately entranced by her imagery and how marvelously she captured the north Florida landscapes and atmosphere.

She was like me, a transplant to Florida, and her love of the north Florida area seemed to be equal to my own. When I read her memoir *Cross Creek*, I was taken back to my childhood, especially when she wrote about the north Florida nights:

The frog Philharmonic of the Florida lakes and marshes is unendurable in its sweetness. I have lain through a long moonlit night, with the scent of orange blossoms palpable as spilled perfume on the air, and listened to the murmur of the minor chords until, just as I have wept over a Brahms waltz in A flat on a master's violin, I thought my heart would break with the beauty of it.

Rawlings was able to capture in print what I understood in my reality. Even though the only deer I have ever seen in this area were in silhouette under the streetlamps of the "brand-new" University of North Florida, where I was taking teacher recertification classes, Rawlings's prose so beautifully captured the essence of my home.

Remembering Jacksonville has been such a treat for me, writing the book as well as reminiscing about my wonderful home in my column. It has been great fun to revisit those old haunts and events that were the cornerstone of a younger generation's independent lives. And I had far more fun reliving old times than I would have had arguing politics or social ills with someone. I loved sitting down with old friends and new and talking about what made us who we are—our schools and our games, our music and our movies, our hangouts and the weather that surrounded them. All of these discussions made for a rosy, glowing feeling by the end of each conversation, and it is my hope that as people read this book I might have jogged the memory and touched on things the reader hasn't thought about or appreciated in ages.

I will admit that as a teenager I really didn't have the proper understanding of how wonderful Jacksonville was. My friends and I were all fired up to go to distant places and do exotic things far from the confines of Jacksonville, but even as a different Dorothy knew, the one lost in Oz, there is no place like home!

Even now, I can listen to the frogs and crickets after storms. They sing in the undergrowth of my yard or in the woods surrounding the San Jose Golf Course a block away from my house. Their music touches me, and the magic carries me back in memory to a simpler, safe time—a time when ice cream cured the heat of the summer afternoon, a ride on a little train was thrilling, the exhilaration of going on a date to the drive-in might cause me to blush or going downtown on the bus to visit Cohen Brothers Department Store was a fabulous excursion. I then remember what it was to be young, amazed by everything around me. I realize also that Jacksonville has been a source of wonder sustaining me and nurturing me as I have grown up and settled in this unassuming but extraordinary place. And like Rawlings, I could weep for the beauty of it.